IMAGES
of America

HISTORIC
BURIAL GROUNDS
OF THE NEW HAMPSHIRE SEACOAST

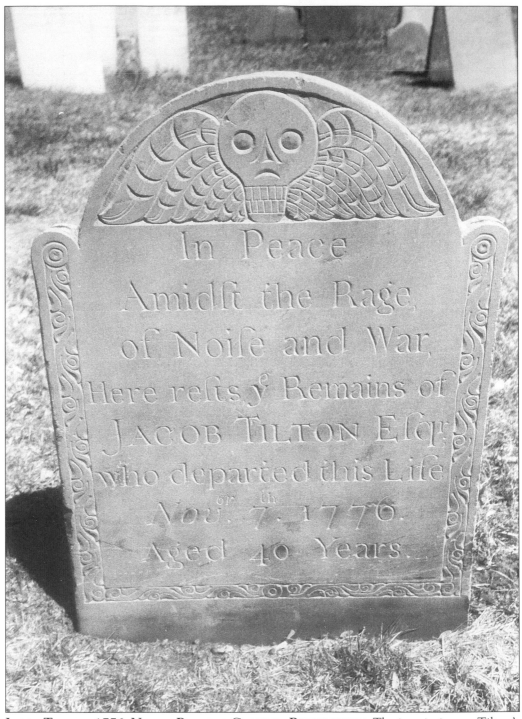

JACOB TILTON, 1776, NORTH BURYING GROUND, PORTSMOUTH. The inscription on Tilton's gravestone reflects the unsettled times and dark days of the early years of the American Revolution, when its outcome was still very much uncertain.

IMAGES
of America

HISTORIC
BURIAL GROUNDS
OF THE NEW HAMPSHIRE SEACOAST

Glenn A. Knoblock

ARCADIA

Published by Arcadia Publishing,
an imprint of Tempus Publishing, Inc.
2 Cumberland Street
Charleston, SC 29401

Printed in Great Britain.

Library of Congress Catalog Card Number: 99-62619

For all general information contact Arcadia Publishing at:
Telephone 843-853-2070
Fax 843-853-0044
E-Mail arcadia@charleston.net

For customer service and orders:
Toll-Free 1-888-313-BOOK

Visit us on the internet at http://www.arcadiaimages.com

ALLICE AYERS, 1717/18, POINT OF GRAVES, PORTSMOUTH. This image is of a gravestone "rubbing" done on the tympanum of Ayers's stone. James Foster was responsible for this winged skull and winged hourglass design.

CONTENTS

ACKNOWLEDGMENTS

This book is dedicated to my daughter Anna, my son John, and my wife Terry, for all their support and encouragement.

The author wishes to thank the following organizations and individuals for their help: the Association for Gravestone Studies, of Worcester, Massachusetts, for allowing me to reprint photographs from my article in *Markers XIII*; Lina Coffey of the Boston Athenaeum, for her help in supplying a copy of the 1704 *Boston News-Letter*, and materials regarding Thomas Story; Betty Moore, director of the Tuck Museum in Hampton, for allowing me to reproduce the sermon by Jeremiah Lane in their collection; Margaret Perry and Elizabeth Lambert Perry for the account book of Benjamin Rowe; the Historical Society of Seabrook, for allowing me to photograph the Bonus Norten and John Stanyan gravestones in their collection; Randa Mace, for lending me her source material on Hampton; Tracy Waldron, librarian, for her help on East Kingston; and Susan Butters, for unknowingly providing the inspiration for this work.

Notes: the reader will note the use of the terms "burying ground" or "burial ground." These terms are deliberately used, as they were the way our colonial ancestors referred to the places where their dead were buried. It was not until after 1800 that the term "cemetery," Greek for "sleeping chamber," was used. The reader will also note the occasional dual dating on gravestones, such as "JAN'ry 1, 1717/18." This was often used on stones dated prior to 1752, when England and her colonies switched from the Julian calendar to the Gregorian calendar, which is the one we currently use. Under the "old style" Julian calendar, the year ran from March to March. Thus, those gravestones with a death date from January to March of a given year, prior to 1752, often list a dual year.

Sources: all photographs are by the author. Many works were consulted in the preparation of this volume. For genealogical references, I have relied on the *Genealogical Dictionary of Maine and New Hampshire* (Baltimore, MD, Genealogical Publishing Co., 1996) by Sybil Noyes, Charles Libby, and Walter Davis, as my primary source. The serious student of gravestones is advised to consult the journal, *Markers*, published annually by the Association for Gravestone Studies. In addition to the above listed works, and standard town histories too numerous to mention, the below listed works have been of particular use.

Forbes, Harriete Merrifield. *Gravestones of Early New England and the Men Who Made Them 1653–1800*. Barre, VT: The Center for Thanatology Research, 1989.

Hammond, Isaac W., ed. *Rolls of the Soldiers in the Revolutionary War*, vols 14-16. Concord and Manchester: Parsons Cogswell and John Clarke, Public Printers, 1885–1887.

Knoblock, Glenn A. "From Jonathan Hartshorne to Jeremiah Lane: Fifty Years of Gravestone Carving in Coastal New Hampshire." *Markers XIII*, Worcester, MA, Association for Gravestone Studies (1996), pp. 75-103.

Lane, James P. *Lane Families of the Massachusetts Bay Colony*. No publisher listed, 1886.

Shipton, Clifford K. *Sibleys Harvard Graduates*, vols. 7-10. Boston: Harvard University Press, 1945–1958.

Fitch, Jabez. *An Account of the numbers that have died of Distemper in the throat within the Province of New Hampshire*. Boston, Ebenezer Russel, 1736.

Caulfield, Ernest. *The Throat Distemper of 1735–1740*. New Haven: Yale Journal of Biology and Medicine, 1939.

INTRODUCTION

The Seacoast region of New Hampshire is one of the oldest settled areas in the country. Nowhere is this age and extensive history more evident than in the old burial grounds of Seacoast area towns. Often forgotten, these burial grounds and the gravestones within them provide our closest and most accessible link to the rich, historic past.

Early settlers buried their dead on their own land. It was usually not until the area was tamed and a town was established that a formal burial ground was laid out. The earliest gravemarkers used were made of wood. Also common were plain stones, placed over a fresh grave to prevent animals from disturbing the remains. These "wolf stones" were moved from place to place as needed.

Three types of gravestones can be found in the Seacoast area. Fieldstone markers are simple pieces of rock or stone, generally left in their natural shape. Often, they have no markings on them, but many are found with crude, home-carved lettering, and a few have some simple ornamentation. These stones were usually carved by family members, such as a husband for his wife, and are one of a kind. Professionally carved gravestones were made by a skilled stonecutter, who is often identified by his distinctive designs. These markers usually came from urban centers such as Boston, Newburyport, or Newport, Rhode Island.

Tablestones are professionally carved gravemarkers that usually measure about 6 feet long by 3 feet wide. They are placed either directly on the ground, elevated on pillars, or walled on all sides. These stones, because of their size and cost, were usually for only the most distinguished or wealthy. It is ironic that most tablestones, because they lie flat and are more exposed to weather extremes, have seldom survived intact. Originally adorned with elaborate coats of arms or inlaid inscriptions, most in the Seacoast area today are illegible. Thus, while the rich man's attempt at immortality is unsuccessful, the common man, with his simple upright gravestone, is still known to us today.

Gravestones were usually supplied in pairs. The most common material used was slate, quarried in Massachusetts, or red or brown sandstone. In addition to the headstone, there was a smaller stone, called a footstone. Together, they marked the boundary of the grave site. The footstone is similar in shape to the headstone, but less elaborately styled, and often have only the initials of the deceased.

The professional carvers whose works can be seen in the Seacoast area can be grouped into two different "schools." The Boston-area carvers were distinctive for their Puritan imagery, such as winged skulls and cherubs, or angels. These Boston-area carvers are the "Old Stonecutter of Boston," William Mumford, "J.N. (possibly John Noyes), Joseph Lamson, his sons Nathaniel and Caleb, James Foster, his son James II, Nathaniel Emmes, his son Henry, John Homer, Henry Christian Geyer, John Stevens II (Newport, Rhode Island), and Paul and Enoch Noyes (Newburyport, Massachusetts).

The Merrimack Valley "school" of carvers are noted for the distinctive circular faces they carved, accompanied by many unusual geometric forms. The earliest works in this style of carving are examples of some of the oldest "folk art" to be found in this country. Those carvers whose works are present in the Seacoast are: the originator of the Merrimack Valley style, John Hartshorne, Robert Mullicken, his son Joseph, Johnathan Leighton, Moses Worcester, Jonathan Hartshorne, grandson of John Hartshorne, and the Websters.

Jeremiah Lane worked in a style that combined elements of both "schools." His work is

present all along the Seacoast, from Dover to Seabrook, though predominant in Exeter, the Hamptons, and Kensington.

In most burial grounds in New England, gravestones are positioned so that they face westward. The body of the deceased, placed between the headstone and footstone, faced to the east. The reasoning for this position was religious in nature. As the sun rises in the east and sets in the west, the deceased was laid out so that they could "see" the dawn of the coming Resurrection. This was an old burial custom brought over from England, dating back to the early days of Christianity.

The symbolism used on gravestones, while morbid to us, is best understood in context with the time in which the gravestones were created. Knowledge of the Bible was common in colonial times. Religious instruction began early in life and was the foundation on which all events, whether commonplace or unusual, were examined and interpreted. The implications of the Bible were spelled out for all to understand, in one way or another. The town minister's Sabbath day sermon was just one way. Gravestones echoed the fiery sermons that were preached. While not everyone could read the Bible, everyone could understand the visual messages set forth upon the gravestone.

The most common symbols on colonial gravestones were the winged skull and the cherub or angel. The winged skull was a dual motif, the skull signifying the certainty of death for all, while the wings symbolized the spiritual aspects of the afterlife. Those gravestones with cherubs or angels depict more hopeful images of the Resurrection and life after death.

In addition to these main motifs, other devices were also used. Symbols of man's mortality include the depiction of implements of death, such as the pickaxe, the shovel, and crossed bones. The drapery depicted on many stones, symbolic of the close of life, is representative of the burial shrouds used. The hourglass was also used to symbolize man's fleeting time in this world.

Symbols used that were more hopeful signs of the afterlife include the elaborate fruit borders, perhaps symbolic of prosperity and happiness in "the Promised Land." Especially common were pomegranates, a symbol of the Resurrection, and the grapevine and bunches of grapes, symbolizing the blood of Christ. Birds, too, often in the form of a peacock, were also depicted. They were symbols of the Resurrection and the "glories of Heaven."

Gravestones are a tangible connection to the past. They possess invaluable information about those whose resting places they mark.

One

DOVER, LEE, DURHAM, AND NEWINGTON

Dover, settled in 1623, is one of New Hampshire's oldest towns. Pine Hill is the site of Dover's third meetinghouse, and the town's second burial ground. In 1711, land on Pine Hill was granted to Rev. Nicholas Sever for a parsonage. Both Sever and his successor, Rev. Jonathan Cushing, lived on Pine Hill. In March 1731, the town voted "that there be one acre and a half of land granted for the use of the town forever, for a public burying place, to be layed out by ye selectmen near ye meeting house on pine hill at cocheca."

Lee, originally part of Dover, became independent in 1766. First Parish Burial Ground, located at the corner of Garrity and Mast Roads, is adjacent to the site of the first town meetinghouse, built prior to 1766.

Durham, first settled about 1635, separated from Dover as a parish in 1675, and became fully independent in 1732. Durham's oldest burial ground, located near the meetinghouse south of Oyster River, disappeared by 1837, when the site of the meetinghouse was sold. The burial ground near the village schoolhouse was not established until 1796. It is likely that the gravestones there that are dated prior to 1796 are remnants of the town's first burial ground, or were relocated from private family lots.

Newington was originally part of Dover and Portsmouth. The old meetinghouse was built in 1712, while the town became independent in 1764. The burial ground adjacent to the meetinghouse has few gravestones remaining that are dated before 1800.

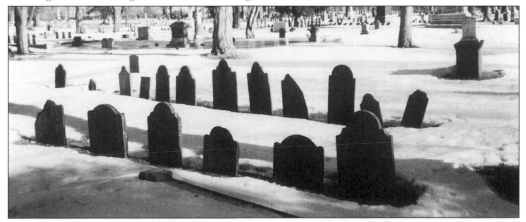

PINE HILL BURIAL GROUND, DOVER. This is the second burial ground established in Dover, dating from 1714. The original town burial ground is on Dover Point Road, but no original gravestones dating prior to 1800 remain.

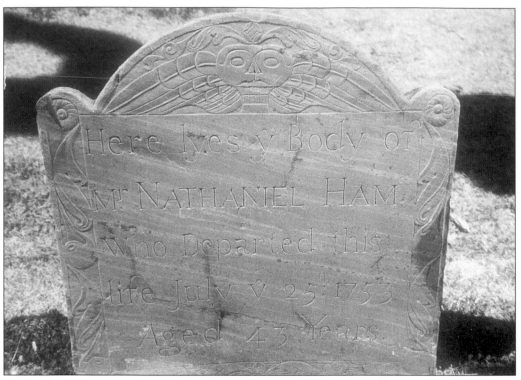

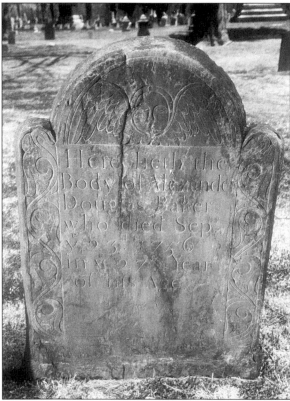

NATHANIEL HAM, 1753, PINE HILL, DOVER. Nathaniel Ham's gravestone has the typical winged skull, and was carved by a member of the Lamson family. The Hams are one of Dover's oldest families, dating back as far as 1665.

ALEXANDER DOUGLAS BAKER, 1756, PINE HILL, DOVER. John Stevens, of Newport, Rhode Island, carved this cherub design.

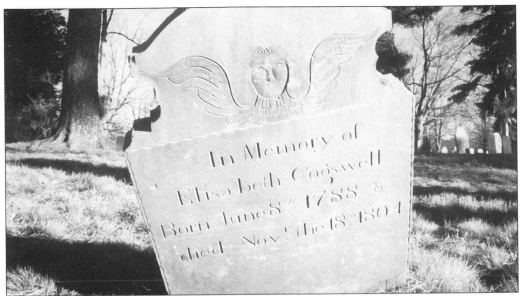

ELISABETH COGSWELL, 1804, PINE HILL, DOVER. Elisabeth's mother was Lydia Cogswell. Prior to her marriage to Col. Amos Cogswell, Lydia was married to Capt. Samuel Wallingford, who was killed in battle on the ship *Ranger*, commanded by John Paul Jones on April 24, 1778. The use of an angel is unusual, as is the shape of the gravestone. At this late date, the weeping willow and urn are seen more often.

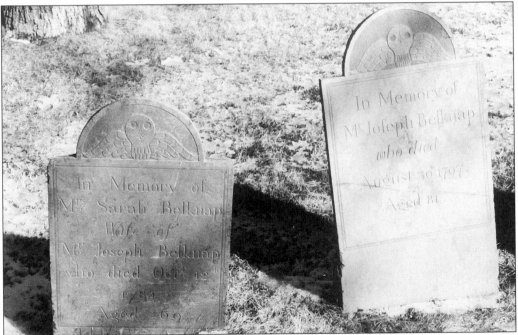

SARAH BELKNAP, 1784, AND JOSEPH BELKNAP, 1797, PINE HILL, DOVER. Sarah and Joseph were the parents of Jeremy Belknap, Dover's 11th and most famous town minister from 1767 to 1786. The former Sarah Byles was related to the famous Mather family of Boston. Joseph was a leatherdresser and furrier. They came to Dover in 1775, at the outbreak of the American Revolution, after Jeremy obtained their release from British-held Boston.

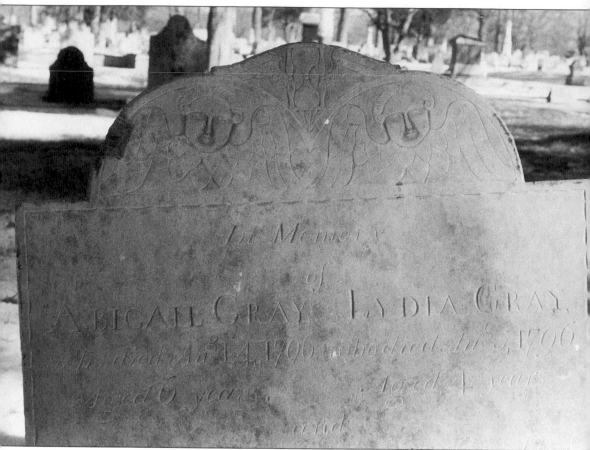

ABIGAIL, LYDIA, AND ROBERT GRAY, 1796, PINE HILL, DOVER. All were the children of Rev. Robert Gray and his wife, Lydia. The two girls died August 1796, within nine days of each other, at ages six and four. Robert died in December 1796, at the age of three months. This gravestone shows the hopeful images of two angels with a heart between them, while the winged hourglass symbolizes the fleeting nature of time. The stone was carved by the Noyes family.

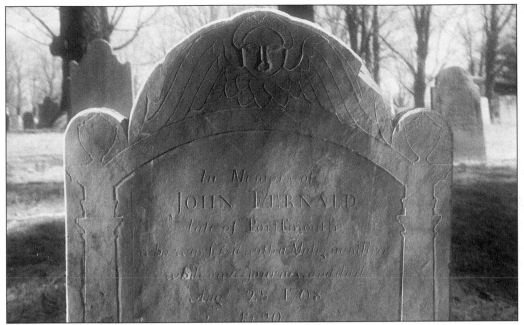

JOHN FERNALD, 1798, PINE HILL, DOVER. Fernald was "late of Portsmouth, who was seized with a Malignant Fever while on a journey and died August 6, 1798 Aet 20." This gravestone was carved by the Noyes family of Newburyport, Massachusetts. Note the columns on either side, topped by funeral urns. The angel is typical of a Noyes carving.

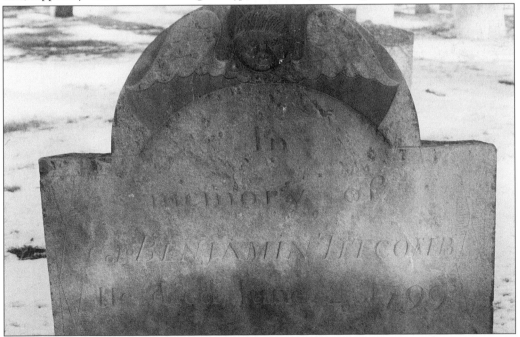

COL. BENJAMIN TITCOMB, 1799, PINE HILL, DOVER. Titcomb was a war hero from Dover who served gallantly in the Revolutionary War. Titcomb was a major in command of the 2nd New Hampshire Regiment, and was severely wounded at the Battle of Hubbardton on July 7, 1777.

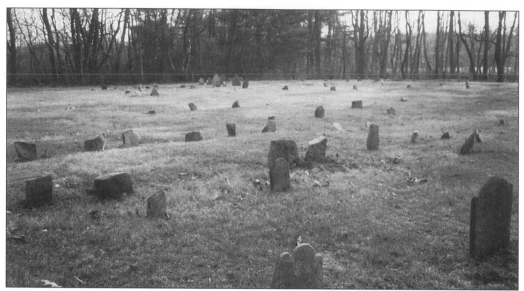

FIRST PARISH BURIAL GROUND, LEE. Many of the gravestones in this rural setting are unmarked fieldstones.

FIRST PARISH BURIAL GROUND, LEE. This undated, unmarked fieldstone is representative of many gravestones from the colonial era. While the family of the deceased knew who was buried here, the passage of time leaves it a mystery to modern day historians.

NATHANIEL RANDEL, 1748, FIRST PARISH, LEE. Randel's gravestone, a typical skull stone by a Boston area carver, was repaired at some point by being encased in concrete.

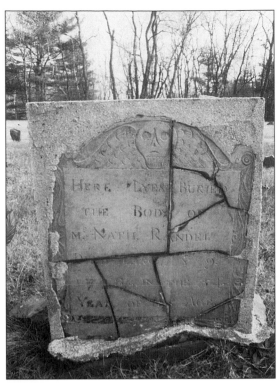

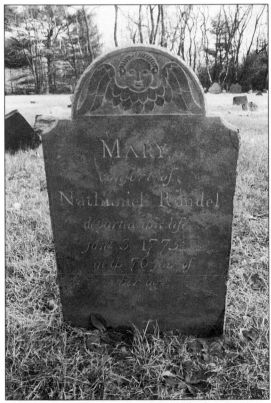

MARY RANDEL, 1775, FIRST PARISH, LEE. Mary Randel's gravestone was carved by the Noyes family. The angel on this stone is typical of their work.

REUSED GRAVESTONES, FIRST PARISH, LEE. The reuse of gravestones was not uncommon in New England, but this example is unusual due to the fact that the old inscription was left intact, no effort being made by the later carver to erase the prior inscription. This stone, dated 1817 on the front, was carved from an earlier, and much larger stone for Betsey Clarke. Her gravestone was probably carved between 1760 and 1790.

SCHOOL HOUSE ROAD BURIAL GROUND, DURHAM. School House Road Burial Ground is the second burial ground established in Durham. This view shows a variety of old stones set in cement, an early method of preservation. The gravestones on this strip all date from 1735 and are the oldest in Durham.

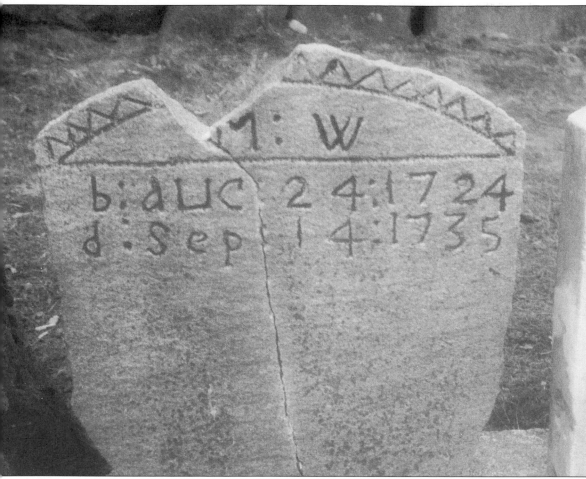

M.W., 1735, SCHOOL HOUSE ROAD, DURHAM. This simply decorated, homemade gravestone was carved for a child, M.W., possibly a member of the Willey family. Undoubtedly, this child died during the Throat Distemper epidemic, which struck Durham in September of 1735. This epidemic, which started in Kingston, New Hampshire, in May 1735, ultimately claimed 94 children aged ten to 20 in Durham before it ran its course. Only the Hamptons, Exeter, and Kingston suffered more deaths. The epidemic spread like wildfire, north into Maine, and south toward Boston, stopping just short of the city. The fear it evoked is reflected in this bit of verse from a pamphlet entitled "Awakening Calls To Early Piety," published in 1738: "To Newbury, O go and See, to Hampton and Kingston, In York likewise, and Kittery, behold, what God hath done."

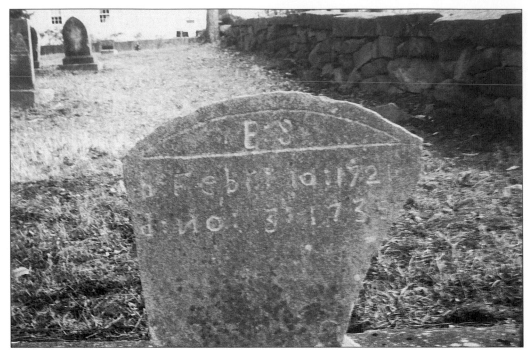

B.S., 1735, SCHOOL HOUSE ROAD, DURHAM. This simple, homemade gravestone was possibly for a member of the Stephenson family. Fourteen-year-old "B.S." was most likely a victim of the Throat Distemper epidemic.

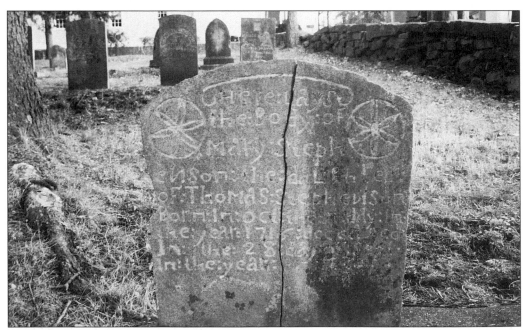

MARY STEPHENSON, 1736, SCHOOL HOUSE ROAD, DURHAM. Mary Stephenson's stone is an unusual example of a decorative homemade gravestone. Crude carvings of acanthus leaves adorn each side. Mary, born in 1716, was the daughter of Thomas Stephenson. She, too, may have been a victim of the Throat Distemper Epidemic.

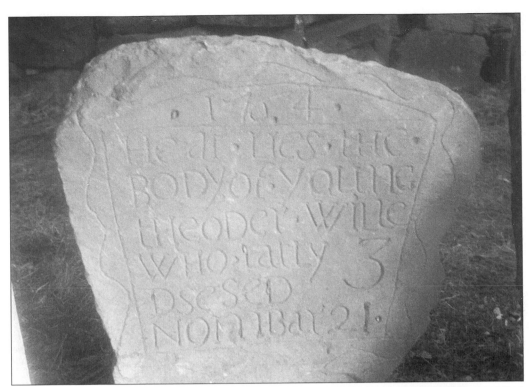

THEODORE WILLE, 1764, SCHOOL HOUSE ROAD, DURHAM. This stone is an outstanding example of a decorative home-carved gravestone. Note the unique spelling in the epitaph. Presumably, Theodore was three years old at the time of his death. The Willey family has roots dating back to 1645 in Durham.

MARGARET SMITH, 1796, SCHOOL HOUSE ROAD, DURHAM. Margaret Smith's stone is a late example of a Lamson family gravestone, with its cursive lettering. This stone cracked into two pieces near its base, and is now held together by iron straps on the back. The iron bolt-heads are visible on the front of the stone.

19

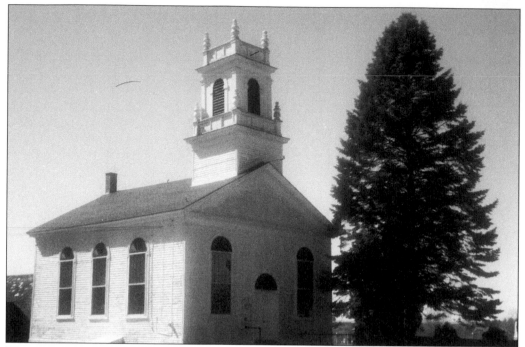

NEWINGTON MEETINGHOUSE, NEWINGTON. The Newington meetinghouse, built in 1712, is the oldest meetinghouse in New Hampshire. Adjacent to the meetinghouse is Newington's oldest burial ground.

COL. JOHN DOWNING, 1759, NEWINGTON. Downing was buried at the corner of the foundation of the Newington meetinghouse. This was a variation of old English custom, when prominent people were buried inside their church. Colonel Downing's prominence is also indicated by the fact that the east door of the church opened to his own private pew and was used only by the members of the Downing family. Though the tomb is dated, and was apparently built in 1759, Downing actually died on February 14, 1766.

Two

Point of Graves Burying Ground, Portsmouth

This historic burial ground, one of the oldest in the state, was formally established in 1671, when the half acre parcel of land was given to the town by Capt. John Pickering. The agreement reads, in part, "that the town shall have full liberty, without any molestation, to enclose about an acre of the neck of land where he now liveth, where the people have been wont to be buried, which land shall be impropriated forever unto the use of a burying-place-only the said Pickering and his heirs forever shall have liberty of feeding the said with neat cattle . . . Provided also that the town or any of them, as there is occasion, shall have liberty to pass over the land of said Pickering to bury their dead." From this agreement, it is seen that Point of Graves was used for burials prior to 1671. John Pickering Sr. was buried here in 1669. It is likely that the practice of grazing cattle in the burial ground resulted in many of the gravestones being knocked down, lost, or damaged.

Point of Graves is a virtual showcase. Not only are many of early Portsmouth's prominent citizens buried here, but many works by early Boston stonecarvers are also present, including William Mumford, "J.N.," James Foster, Nathaniel Emmes, and Caleb Lamson. The oldest remaining gravestone in Point of Graves is dated 1682, while the latest date to the 1840s.

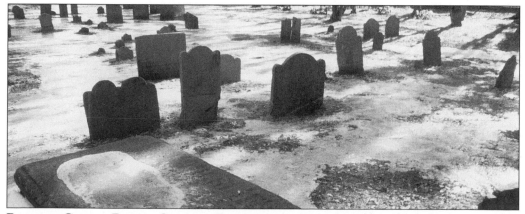

POINT OF GRAVES BURIAL GROUND, PORTSMOUTH. Note the tablestone in the foreground of this view of Point of Graves Burial Ground. Several tablestones are found here, but all are nearly illegible.

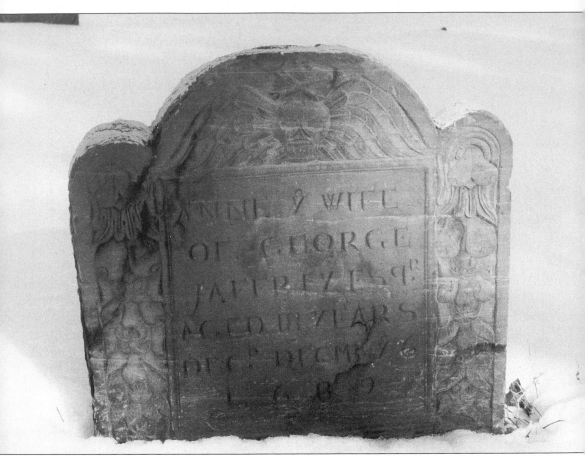

ANNE JAFFREY, 1682, POINT OF GRAVES, PORTSMOUTH. This gravestone is one of the oldest in New Hampshire. Its carver is unknown, but it may have been the "old stonecutter of Boston," or William Mumford. Note the elaborate borders of leaves and fruit. Little is known of Anne Jaffrey's life. Her husband, George Jaffrey, was a Scottish merchant who first came to Boston, then the Piscataqua area by 1676. In 1679, he was living on Great Island, and is listed as a shipowner in 1681. In October 1682, one of Jaffrey's vessels, a ketch, was seized and condemned for a breech of the Acts of Trade. It is likely that Anne died due to complications of childbirth, as her son George Jr. was born on November 22, 1682, two weeks before her death.

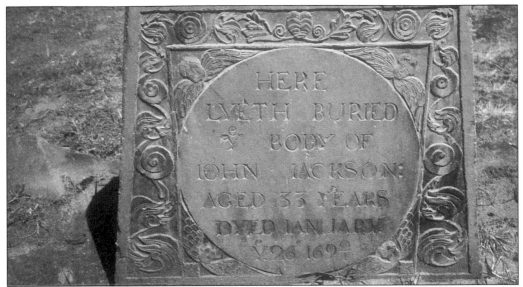

JOHN JACKSON, 1690/91, POINT OF GRAVES, PORTSMOUTH. This elaborate stone was made by an early Boston carver, possibly the man known as "J.N." It is unusual for its shape, as well as its overall design. Note the cherubs in each corner (see detail below) and the heart at the top center of the stone. Jackson was a mariner of Portsmouth, who was married to Margaret Clark. He had a son John Jr., to whom he willed his house, 39 acres of land, and 5 acres of salt marsh on "Littel harbor" once "hee comes to Lawful age of twenty-one years." He also willed to his wife 14 acres of land and "too acers of land upon the Letill Iland comm'only called Jackson's Island."

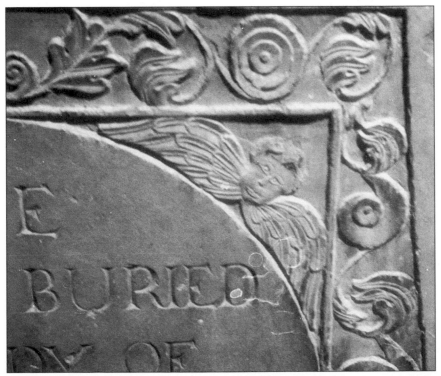

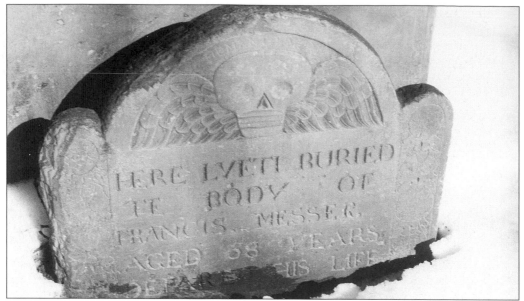

FRANCIS MESSER, 1692, POINT OF GRAVES, PORTSMOUTH. William Mumford of Boston carved this gravestone. Note the words "Memento Mori," Latin for "Remember Death," carved above the skull. This Puritan slogan, commonly used in the Boston area, is rarely seen on Seacoast area gravestones. Messer was a carpenter of Portsmouth. His wife, Gertrude, was a midwife. In 1685, Robert and Rebecca Smart of Newmarket sold the Messers an African-American child, whose life Gertrude had saved during childbirth.

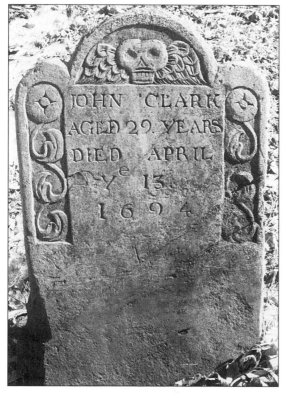

JOHN CLARK, 1694, POINT OF GRAVES, PORTSMOUTH. This gravestone is the work of William Mumford of Boston. It is a smaller version of some of Mumford's more elaborate stones. Clark was a housewright who lived on Doctors or Clark Island.

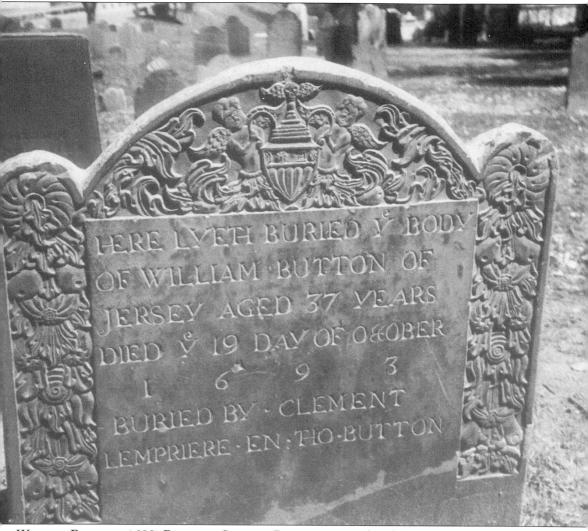

WILLIAM BUTTON, 1693, POINT OF GRAVES, PORTSMOUTH. This elaborate stone was carved by a man known only as "J.N.," and has been restored in recent years. Button was an English merchant with a large business on the Piscataqua River. He met his death by drowning, probably after falling overboard from his ship *Lyon*. The inscription includes the names of the two men who buried him, Clement Lempriere, a sea captain of the Island of Jersey, and Thomas Button, William's brother. At his death, Button left an estate valued at 1490 pounds, a very large sum in those days. The details on this stone are striking. Note the funeral urn in the center topped with a small-winged skull, flanked by cherubs. The intricately carved side borders depict pomegranates and gourds amidst an abundance of leaves. Button's gravestone leaves no doubt to his wealth and standing in the community.

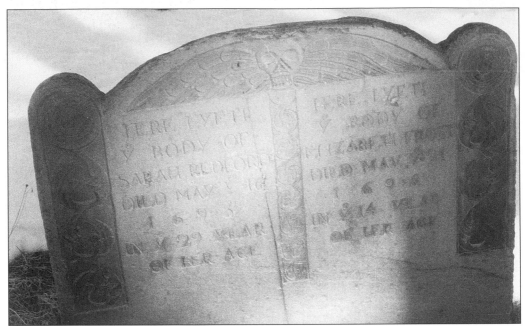

SARAH REDFORD, 1695, AND ELIZABETH FROST, 1696, POINT OF GRAVES, PORTSMOUTH.
William Mumford, a Quaker of Boston, carved this double gravestone. The women were sisters,
the daughters of Major Charles Frost. Sarah married William Redford, a distinguished man who
served as provincial secretary. Major Frost was equally distinguished. He served as a sergeant-
major for all of Maine from 1682 to 1688, and as a judge of the Common Pleas Court. He died
on July 4, 1697, as a result of an "Indian" ambush on his way home from meeting.

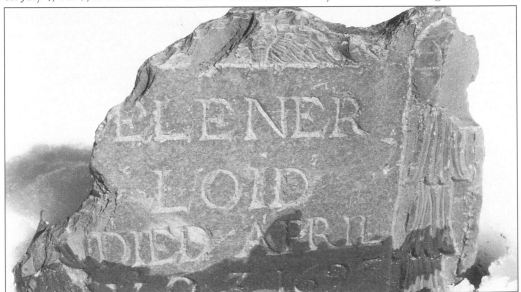

ELENER LOID, 1697, POINT OF GRAVES, PORTSMOUTH. There is a tiny skull at the top of this
small gravestone, which was carved by William Mumford of Boston. The stone was thought to
be lost prior to a 1904 survey, but was rediscovered by John Knoblock in 1994. The stone had
become almost completely buried. Elener was the daughter of Francis Messer and was married to
Portsmouth mariner Allen Lyde.

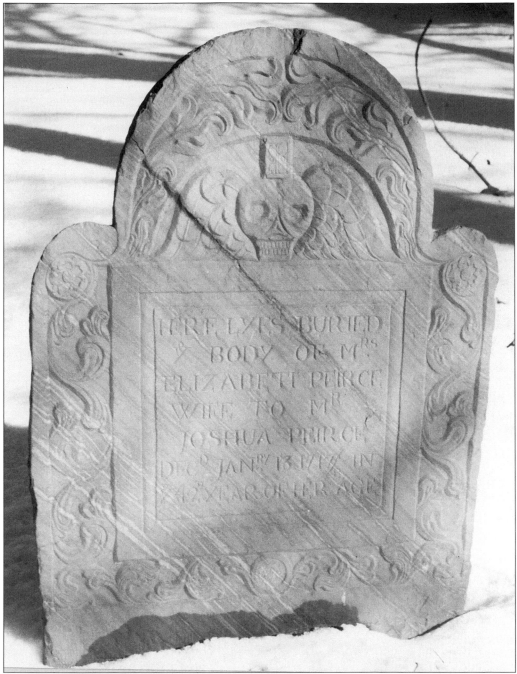

ELIZABETH PEIRCE, 1717, POINT OF GRAVES, PORTSMOUTH. Elizabeth Peirce's stone is a fine example of a uniquely shaped tympanum. The tympanum, the arched upper portion of a gravestone, provides the "canvas" for the carver's work. Note the hourglass above the winged skull, and the swirling designs, which follow the high arch of the stone. The skull and hourglass are stark reminders of man's mortality, while the swirling forms above and on the borders are symbolic of redemption and salvation to follow. This stone is likely the work of Nathaniel Emmes of Boston.

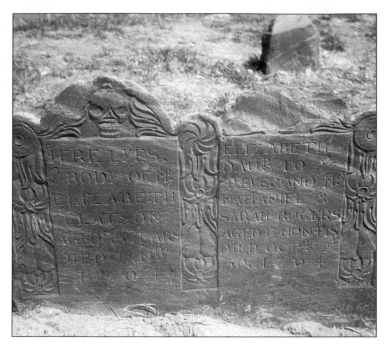

ELIZABETH ELATSON AND SARAH ROGERS, 1704, POINT OF GRAVES, PORTSMOUTH. Likely the work of William Mumford, this gravestone has a sad tale to tell. On October 30, 1704, Rev. Nathaniel Rogers's house caught fire in the middle of the night. Mrs. Rogers's mother, Elizabeth Elatson, tried to save her granddaughter, Sarah. But it was not to be. Little Sarah died that night. Mrs. Elatson survived the fire, but died of her injuries in January.

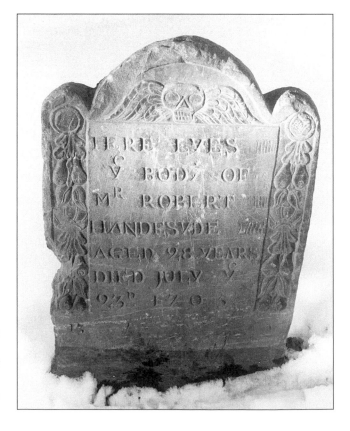

ROBERT HANDESYDE, 1705, POINT OF GRAVES, PORTSMOUTH. This diminutive gravestone was probably the work of William Mumford. Note the elaborate side borders, as well as the carver's marks on the very bottom of the stone. The number '13,' on the lower left, is likely the price paid for this gravestone, 13 shillings.

The Boſton News-Letter

Publiſhed by Authority.

From Monday October 3ø. to Monday November 6. 1704.

, Entered Outward Bound, *Tobias Green* in the
er, and *Nicholas Parker* in the *Elizabeth* for *Ja-*
Forreign Inwards, *Joſhua Corniſh* in the *Unity*,
nſilvania, *Moſes Sweet* in the *Tryal*, and *Moſes Abbot*
yal from *Coratuck, Nicholas Parker* in the *Elizabeth*,
n *Scot* in the *Unity* from *Barbadoes,* Forreign
ds. *Nicholas Thomas Jones's* Sloop *Speedwell* for
ia, and *Peter Leach* in the *Prudent Sarah* for *Ne-*
oaſters Outwards Cleared, *John Keirſteed* in the
d *Sarah* for *New-York, John Jackſon* in the *Speed.*
Piſcataqua, and *Simon Grover* in the *Primroſe* for
cut.
ryday night the 3d Currant returned from *Albany*,
ourable Colonel *Penn Townſend,* and *John Leveret*
Commiſſioners for a Treaty with the 5 Nations,
other Gentlemen that accompanied them, all in
alth, who have renewed the ancient Friendſhip

Piſcataqua, Novemb. 2. On *Monday* the 3 o h laſt abou
break of day, the Houſe of the Reverend Mr. *Nathan*
Rogers, Miniſter of *Portſmouth,* was burnt to the Groun
in a few minutes, his youngeſt Child, and a Negro Wo
man of Mrs. *Elaſons,* his Mother-in-law, conſumed in th
Flames, nothing ſaved but himſelf, his Wife, Mother-in
law, two Children, and the Servant-Maid, as they got ou
of Bed without Cloaths; Mrs. *Elaſon* ſaved the elder
Child by throwing him out of a Chamber Window int
his Fathers Arms, and immediately thereafter Mr. *Rger*
got a Ladder for his Mother-in-law, and ſo got her out a
the Window, who is much burned in her Legs & Arm
but think not dangerous to life. None can tell how th
Fire came, moſt probably it began in their Kitchen; th
Fire was ſo violent by reaſon of the high Wind, that ha
there been never ſo many People to quench it, and help t
ſave the Goods, 'twere impoſſible to ſave any thing.

EXCERPT, THE BOSTON NEWS-LETTER, NOVEMBER 6, 1704. The *Boston News-Letter* was the first newspaper published in the American colonies, starting early in 1704. It published news from England and Europe, as well as from other places, including the "Forreign" colonies of Pennsylvania and the Barbadoes. This issue contains news regarding Portsmouth on page two. In the right column is the account of the fire that destroyed the house of Rev. Nathaniel Rogers, claiming the life of his daughter, an African-American servant, and, ultimately, his mother-in-law. This is the first published account of a house fire in the American colonies. It states that Mrs. Elaston was "much burned in her Legs & Arms, but think not dangerous to life." This information proved optimistic. (See opposite page.)

29

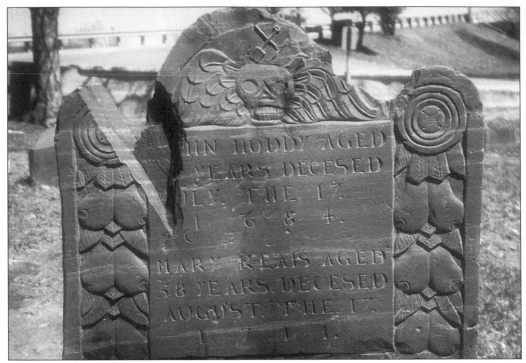

JOHN HODDY, 1684, AND MARY KEAIS, 1711, POINT OF GRAVES, PORTSMOUTH. Boston area carver Joseph Lamson may have carved this double gravestone. Note the fruit borders and the pickax and shovel above the winged skull. John Hoddy was a Portsmouth mariner who was born in 1648 and lived in the Strawberry Banke area. He married Mary Riddan on June 21, 1675. After John's death, Mary was a licensed retailer in 1686, 1692, and 1694. She had a tavern license in 1693. She remarried Samuel Keais.

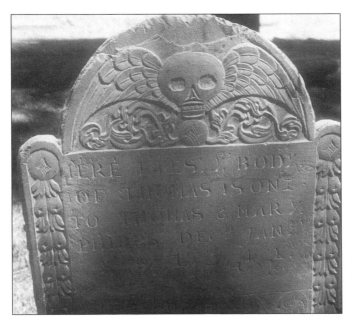

THOMAS PHIPPS, 1712, POINT OF GRAVES, PORTSMOUTH. This gravestone, the work of a Boston area carver, is unusual for two reasons. First, note the pointed wings on the menacing-looking skull and the swirling designs underneath them. Secondly, note the faintly carved writing on the right edge and above the word "body." This indicates a reused gravestone with its previous lettering "erased" and a new epitaph carved. Thomas was the son of the town schoolmaster.

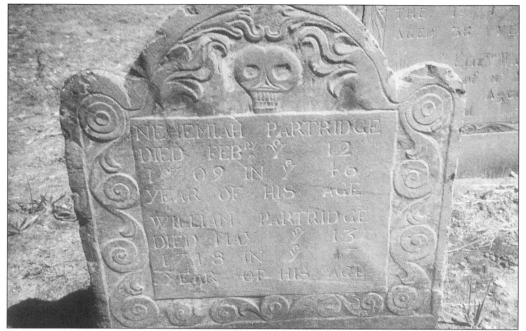

NEHEMIAH PERTRIDGE, 1709, AND WILLIAM PARTRIDGE, 1718, POINT OF GRAVES, PORTSMOUTH. William Partridge was the son of Nehemiah, a cordwainer of Portsmouth. Records state that Nehemiah died in February 1691, not in 1709, as stated on this stone which was carved after William's death in 1718.

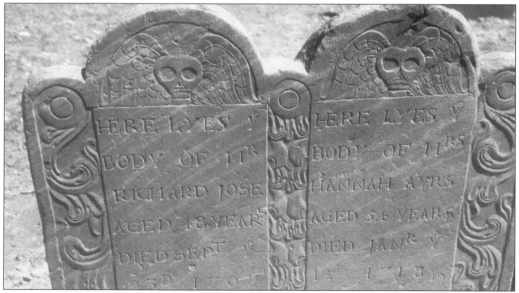

RICHARD JOSE, 1707, AND HANNAH AYRS, 1718/19, POINT OF GRAVES, PORTSMOUTH. This double gravestone was probably carved by Nathaniel Emmes of Boston. The stone was not erected until Hannah's death, 12 years after Richard's. His family inheritance included all of the Isles of Shoals property. He married Hannah, the widow of Richard Martyn, on October 16, 1683. After Richard's death, Hannah married again, to Edward Ayers, on October 2, 1718, but died shortly thereafter.

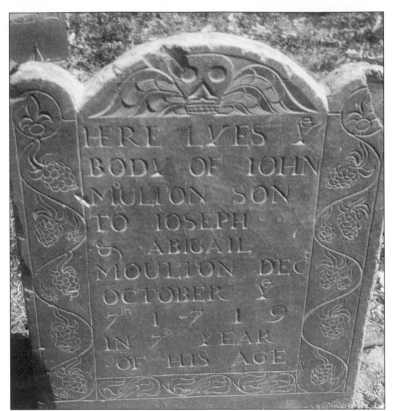

JOHN MOULTON, 1719, POINT OF GRAVES, PORTSMOUTH. James Foster carved this young boy's gravestone. Note the grapevine clusters and vine decorating the side borders. He and his father, of York, Maine, were taken captive by "Indians" in 1691/92 during raids made in the area. His father died in captivity, while Joseph was released. Joseph later became a blacksmith in Portsmouth.

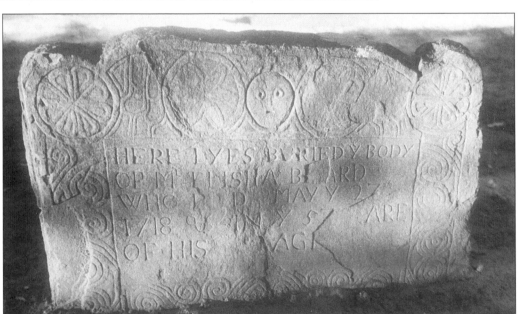

ELISHA BRIARD, 1718, POINT OF GRAVES, PORTSMOUTH. This interesting gravestone is the work of John Hartshorne. Note the round face in the center, flanked by circles of acanthus leaves and pie-shaped designs. Briard worked in the shipfitting trade as a blockmaker. He was paid by the town of Portsmouth in 1698 for making "old Richard Lewis's" coffin.

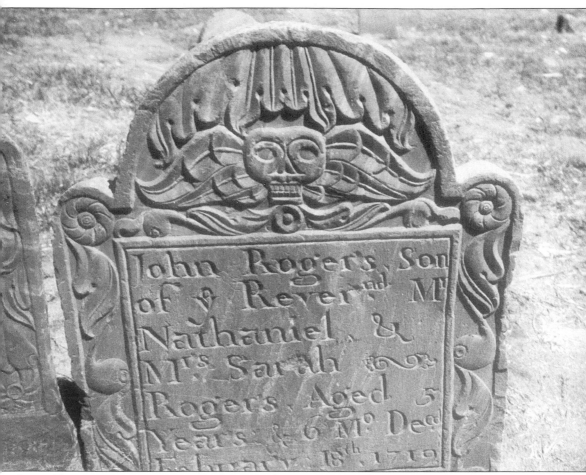

JOHN ROGERS, 1719, POINT OF GRAVES, PORTSMOUTH. John Rogers's gravestone is an example of Caleb Lamson's work. Note the initials, C.L., in small lettering on either side of the disc on which the winged skull rests. Young John Rogers was the son of Rev. Nathaniel Rogers, the second minister of Portsmouth, whose father was the president of Harvard University. Nathaniel graduated from Harvard in 1687. He began preaching in Portsmouth in 1697 and served there until his death in 1723. The tablestone marking Reverend Rogers's grave is nearby, but the inlaid inscription was lost or destroyed prior to 1900.

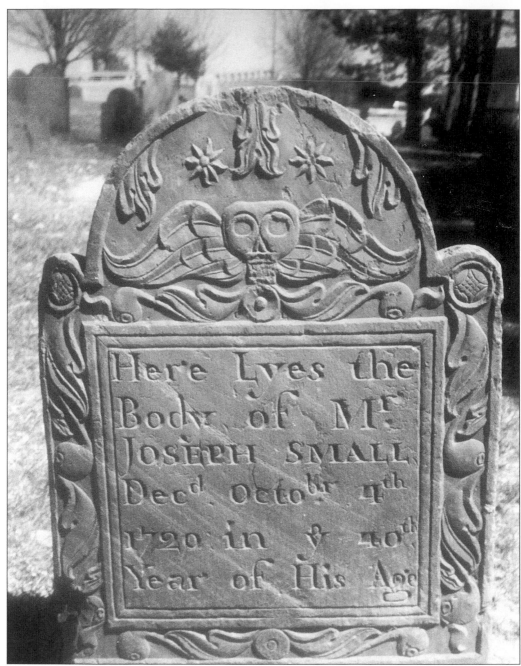

JOSEPH SMALL, 1720, POINT OF GRAVES, PORTSMOUTH. While almost nothing is known of Joseph Small's life, his gravestone is a unique example of the stonecarver's art. Carver Caleb Lamson's initials were placed to each side of the disc on which the winged skull rests. It is not known whether he did this for artistic or advertising purposes, or perhaps both. These seven "initialed" stones by Caleb Lamson in Point of Graves all dated from 1719 to 1721. There dates coincide with Caleb starting in the stonecutting business on his own after his father, Joseph Lamson's, retirement. Only five other stones signed by Caleb Lamson are known to exist outside Point of Graves, four in Massachusetts, and one in Connecticut.

BENJAMIN ALLCOCK, 1720, POINT OF GRAVES, PORTSMOUTH. The initials, C.L., above the winged skull on this stone are carver Caleb Lamson's identifying marks. The crude carving technique and poor spelling employed on this gravestone reveal the inexperience of a young carver. Benjamin's mother, Keturah, lived until 1754.

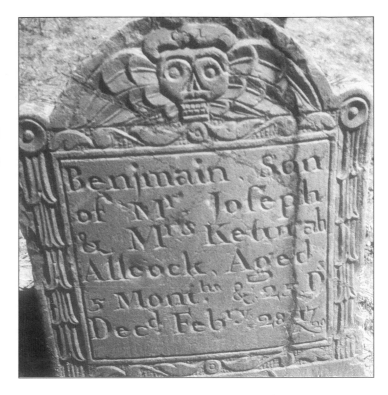

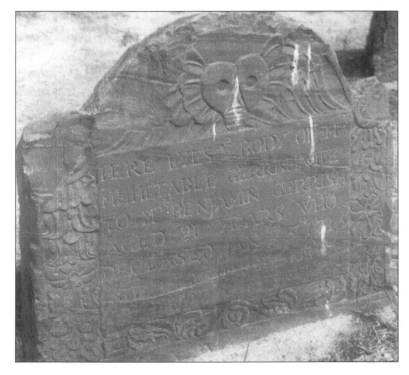

MEHETABLE GERRISH, 1715, POINT OF GRAVES, PORTSMOUTH. Mehetable Gerrish's stone was carved by an early Boston area carver. Note the elaborate fruit borders and the distinctive wings on the skull. Mehetable was baptized at North Church in Portsmouth on December 16, 1694. She was the daughter of Col. John Plaisted, a wealthy merchant of Portsmouth. She married Benjamin Gerrish, a gunsmith, in 1711.

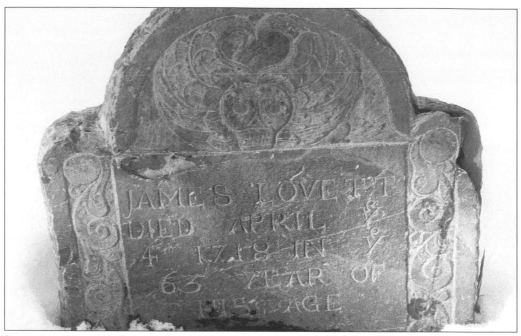

JAMES LOVETT, 1718, POINT OF GRAVES, PORTSMOUTH. Nathaniel Emmes of Boston carved this unusual stone. Note how the wings of the skull curve up and over to form a heart. Lovett was originally from Hampton. He "made a confession of Faith" and was baptized in the church there on October 11, 1668. He worked as a shopkeeper and bookeeper for John Cutt of Portsmouth.

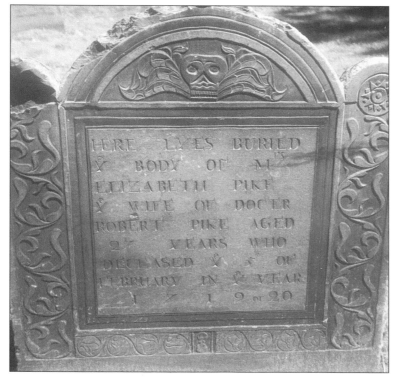

ELIZABETH PIKE, 1720, POINT OF GRAVES, PORTSMOUTH. Mrs. Pike's stone is an example of an elaborate work by James Foster. The former Elizabeth Atkinson was married to Dr. Robert Pike, a son of the Reverend John Pike, the prominent minister of Dover, on May 22, 1711. Elizabeth and Robert had three sons, all of whom were deceased by 1738.

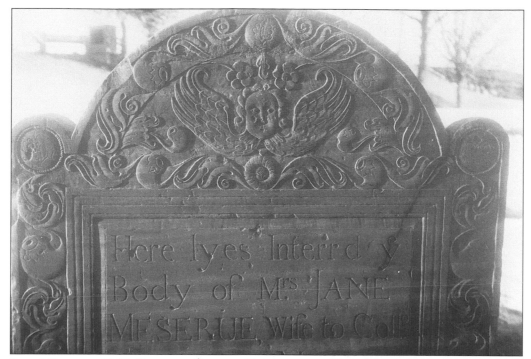

JANE MESERVE, 1747, POINT OF GRAVES, PORTSMOUTH. This elaborate stone by the Lamson family is nearly 4 feet tall. Jane's husband, Col. Nathaniel Meserve, was one of Portsmouth's outstanding soldier-citizens. He served in the Siege of Louisburg in 1745, and, in 1749, he was commissioned by the British to build a 50-gun warship called the *America*. In 1756, he commanded the New Hampshire regiment raised for the Crown Point Expedition and gallantly defended Fort Edward. However, smallpox broke out, and he, along with most of his regiment, died.

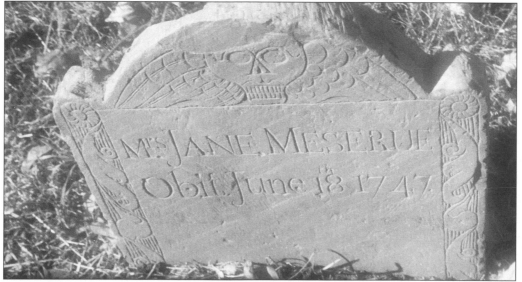

FOOTSTONE, JANE MESERVE, 1747. While the headstone is decorated with numerous hopeful images of life after death, Mrs. Meserve's footstone retains the traditional winged skull.

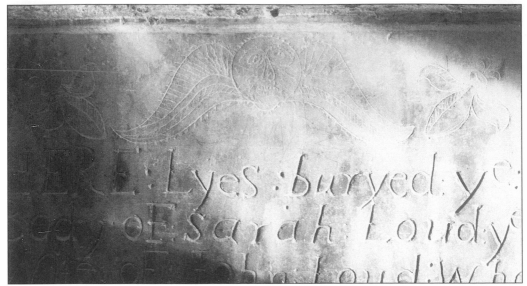

SARAH LOUD, 1738, POINT OF GRAVES, PORTSMOUTH. Note the homely cherub and fleur de lis on this homemade gravestone. Sarah married John Loud, a cordwainer of Portsmouth, prior to 1734. They had three children, twins Abigail and Sarah, baptized on February 3, 1733/34, and another daughter, Sarah, baptized on February 15, 1735/36.

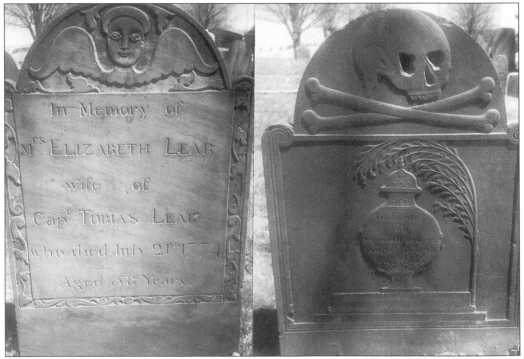

ELIZABETH LEAR, 1774, AND CAPT. TOBIAS LEAR, 1781, POINT OF GRAVES, PORTSMOUTH. The Lamsons carved Elizabeth's cheerful stone, while Tobias' gravestone was the work of John Homer. Note the realistic skull and crossbones, with the urn and willow below. The former Elizabeth Hall married Lear, a mariner of Portsmouth, on December 13, 1733. They had three children, including Tobias Jr., who gained fame as George Washington's private secretary.

Three

NORTH BURYING GROUND, PORTSMOUTH

North Burying Ground lies on land purchased by the town of Portsmouth from Col. John Hart in 1753, for 150 pounds. Hart, a Portsmouth blacksmith, was the commander of the New Hampshire Regiment in the Lake George campaign during the French and Indian War in 1758. This burying ground is famous for the many notable men of the Revolutionary era of Portsmouth who are buried here, including signer of the Declaration of Independence Gen. William Whipple, his slave Prince (who fought in the war to earn his freedom), signer of the Constitution Gov. John Langdon, and commander of the Continental frigate *RALEIGH* Capt. Thomas Thompson. Also found buried here, as evidenced by their elaborate and unique gravestones, are many of 18th-century Portsmouth's mercantile elite. Portsmouth's maritime ties to Boston are well-documented by the many Boston area carved stones found here.

NORTH BURYING GROUND, PORTSMOUTH. This burial ground, located on Maplewood Avenue, was placed on the National Register of Historic Sites in 1978.

ELIZABETH STOODLEY, 1757, NORTH BURYING GROUND, PORTSMOUTH. James Foster II carved this unusual gravestone with its cameo-style tympanum. Elizabeth, age eight at the time of her death, was the daughter of well-known Portsmouth hotel-keeper James Stoodley.

ELIZABETH HART, 1761, NORTH BURYING GROUND, PORTSMOUTH. Elizabeth Hart's stone was carved in the Merrimack Valley style by Joseph Mullicken. The angel has a small bonnet on its head, symbolizing that this is a woman's gravestone. The former Elizabeth Cotton married Thomas Hart on July 15, 1731. Her father, William Cotton, was a tanner of Portsmouth.

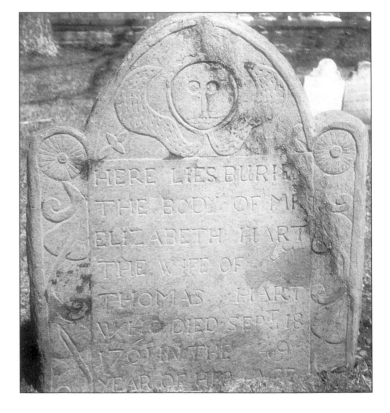

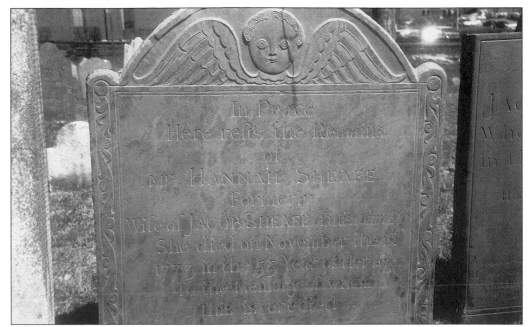

HANNAH SHEAFE, 1773, NORTH BURYING GROUND, PORTSMOUTH. This stone, with its wide-eyed angel, is the work of the Lamson family. Hannah was the wife of Jacob. The Sheafes were a prominent merchant family in Newcastle and, later, Portsmouth.

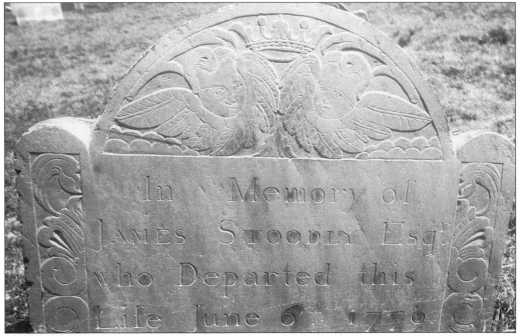

JAMES STOODLY, 1779, NORTH BURYING GROUND, PORTSMOUTH. Henry Christian Geyer of Boston carved this unusual gravestone. Note the two male cherubs with quirky expressions, the crown above them, and the clouds below on either side. Stoodly was a well-known hotel-keeper in Portsmouth. His three-story hotel on Daniel Street was also used for public balls and Masonic meetings before catching fire in 1761.

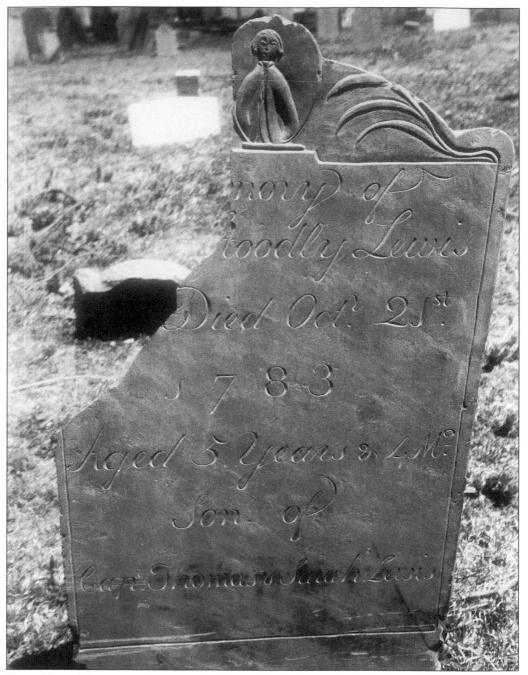

First Name Unknown Stoodly Lewis, 1783, North Burying Ground, Portsmouth.
Though partially broken, this stone is a fine example of a portrait stone, carved by the Lamson family. It is one of only two such stones in the Seacoast area. Note the details on the carved figure, such as the coifed hair and the collared waistcoat. The figure is an idealistic portrait of the deceased young man, yet accurate in its details, as even young boys dressed like adults in those times.

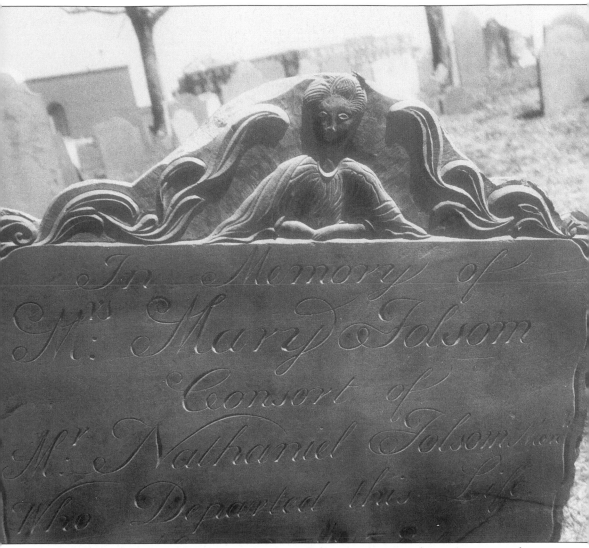

MARY FOLSOM, 1782, NORTH BURYING GROUND, PORTSMOUTH. Another portrait stone by the Lamson family, this gravestone is exquisitely carved. Note the textured hair, the flowing folds of the dress, and the tiny hand. The elegant cursive lettering used for the inscription adds to the stone's appeal. Mary was the daughter of James and Elizabeth Stoodley. She married Nathaniel Folsom on November 26, 1771.

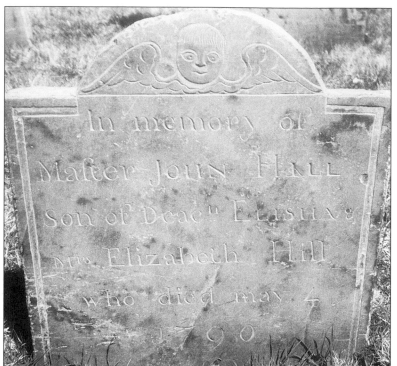

JOHN HILL, 1790, NORTH BURYING GROUND, PORTSMOUTH. John Hill's simple, yet charming gravestone is possibly the work of the Lamson family. Note the use of the title "master" for a youth.

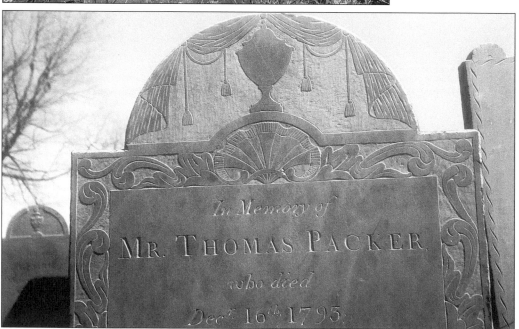

THOMAS PACKER, 1793, NORTH BURYING GROUND, PORTSMOUTH. Note the funerary urn and drapery, symbolic of the end of life, decorating the tympanum of Packer's stone. It was carved by the Noyes family. Packer was the son of another Thomas Packer, who was Portsmouth High Sheriff and associated by marriage to Lt. Gov. John Wentworth. When the elder Packer died in 1771, he willed his property to Lt. Gov. John Wentworth, which the younger Thomas Packer contested.

MARY PEARNE, 1788, NORTH BURYING GROUND, PORTSMOUTH. Mary Pearne's gravestone, by Enoch Noyes, of Newburyport, Massachusetts, is more elaborately carved than most of his works. While the angel at the top is typical, note two additional angels on top of the ornate side columns. This stone is all the more unusual because the carver signed it.

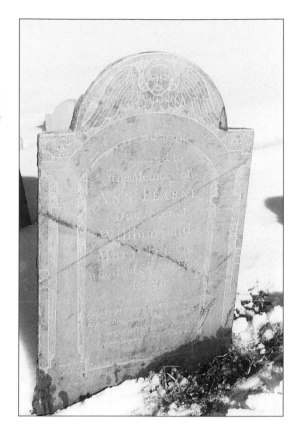

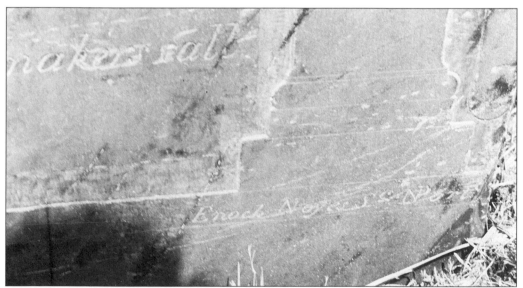

ENOCH NOYES'S SIGNATURE, NORTH BURYING GROUND, PORTSMOUTH. Stonecarver Enoch Noyes signed this stone, "Enoch Noyes SCNPort." SC stands for stonecarver, Nport for Newburyport, Massachusetts.

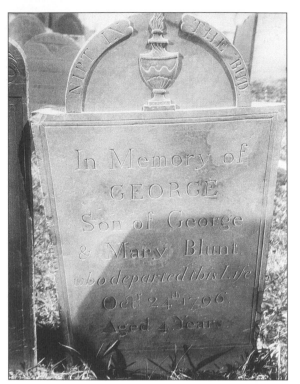

GEORGE BLUNT, 1796, NORTH BURYING GROUND, PORTSMOUTH. The inscription on this stone conveys its message in phraseology still used today. The motif of a funeral urn with an eternal flame was common by the end of the 18th century.

JOANNA PARRY, 1800, NORTH BURYING GROUND, PORTSMOUTH. This partially repaired stone, with its coffin-shaped inset missing, is probably the work of the Lamson family. The inscription reads, in part, "resigned her soul into the hands of God the 10th of June, AD 1800, 27 years after the beauteous clay had been inspired by His spirit: five and a half of which had been passed in happy wedlock with a husband who loved her virtues . . ."

ELIZABETH HALLIBURTON, 1807, NORTH BURYING GROUND, PORTSMOUTH. The work of an unknown carver, this appealing gravestone reflects the softened attitude toward death. Gone are the skulls and crossbones on the graves of children, replaced by more hopeful, peaceful imagery. Of special note are the small bird at the top and the use of the word "dutiful."

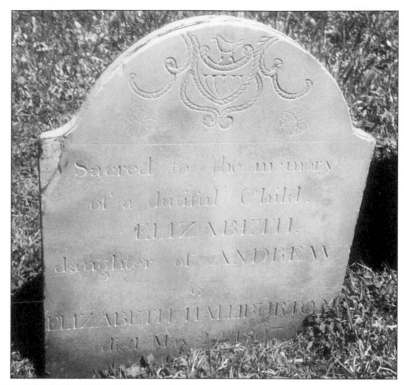

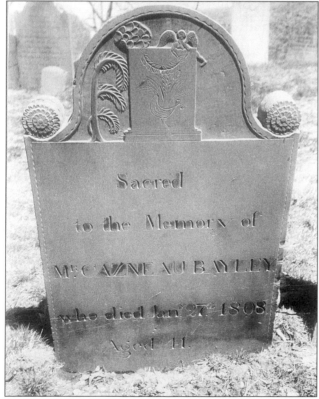

CAZNEAU BAYLEY, 1808, NORTH BURYING GROUND, PORTSMOUTH. The carver of this creative stone is unknown. Note the rather awkward looking angel and the bird with tulips and foliage above it. Cazneau Bayley was a prominent Portsmouth merchant.

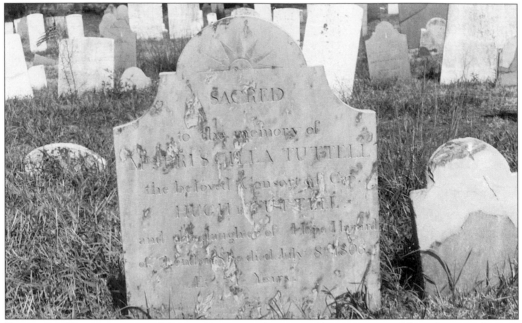

PRISCILLA TUTTELL, 1806, NORTH BURYING GROUND, PORTSMOUTH. Note the straight rays on the sun compared to the wavy rays on the Spinney stone (below).

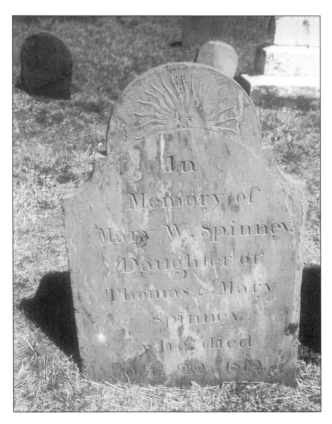

MARY SPINNEY, 1812, NORTH BURYING GROUND, PORTSMOUTH. Mary Spinney's gravestone and that of Priscilla Tuttell (photograph above) are of uncertain origin, although possibly the work of a Newport, Rhode Island area carver. Only two stones with the sun motif are known to exist in the Seacoast area, both in this burial ground. The sun motif provides dual symbolism, the end of life, depicted by the setting sun, and the soul's ascent to heaven, portrayed by the sunrise.

Four

SOUTH STREET CEMETERY

ST. JOHN'S CHURCHYARD, AND PLEASANT STREET BURYING GROUND, PORTSMOUTH

South Street Cemetery contains several old burial grounds. The Cutts-Penhallow portion is in the center, within a grove of trees that was originally an orchard, located "a few rods west of the President's house." John Cutt was the first president of New Hampshire's Provincial Court.

The Cotton burying ground is in the northern portion of South Street Cemetery. It lies on land granted to "Goodman" William Cotton in 1671. Cotton was allowed to use the land as pasture for 20 years, in return for his work in clearing and fencing it in. It was also stipulated that "the said land shall still remayne for a trayning field and to bury dead in." This land was later called the "Minister's Pasture," when its use as a training field was discontinued.

The land encompassed by South Street Cemetery is one of Portsmouth's most historic spots. It was here, on December 30, 1768, that Ruth Blay, of South Hampton, was executed for concealing the death of her illegitimate child, in front of thousands of spectators.

St. John's churchyard dates to approximately 1732, when the original church on this site, Queen's Chapel, was built. Queen's Chapel burned down on December 24, 1806, and St. John's Church was built on the same spot shortly thereafter.

The Pleasant Street burying ground was deeded to Portsmouth in 1754 and is situated on what was once called "Pickerings Neck," a portion of John Pickering Sr.'s original landholdings.

SOUTH STREET CEMETERY, PORTSMOUTH. This view of the South Street Cemetery shows an older portion, dating back to the 1740s.

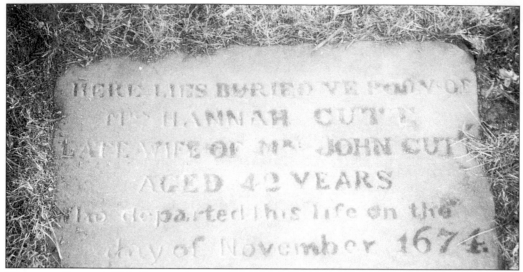

HANNAH CUTT, 1674, SOUTH STREET, PORTSMOUTH. Mrs. Cutt's tablestone is in the Cutts-Penhallow section of South Street Cemetery. Hannah was baptized in 1632 at Ashford, County Kent, England, the daughter of Dr. Comfort Starr, later of Boston. She married John Cutt on July 30, 1662. John Cutt was a prominent colonial official in Portsmouth and became the president of the Provincial Court in 1680.

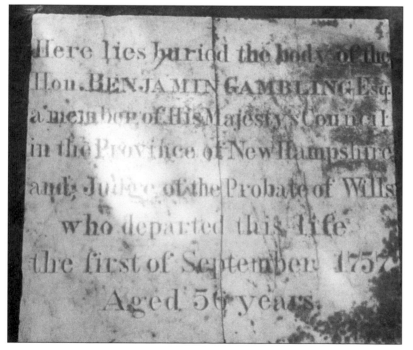

BENJAMIN GAMBLING, 1757, SOUTH STREET, PORTSMOUTH. This photograph shows the inset stone from Gambling's tablestone, which lies in the Cutts-Penhallow burial ground within South Street Cemetery. Gambling was married to Mary Penhallow, daughter of Samuel Penhallow, one of America's early historians.

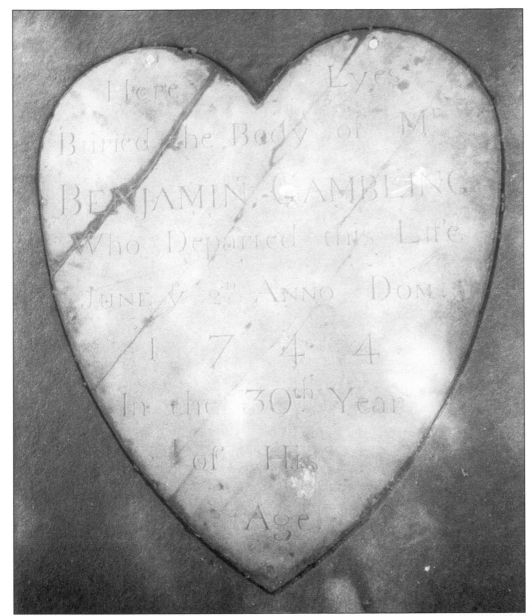

BENJAMIN GAMBLING, 1744, SOUTH STREET, PORTSMOUTH. The heart-shaped inset found on this tablestone is remarkably well preserved. Few tablestones have survived the years in this part of the country due to the harsh weather conditions. This stone is found in the Cutts-Penhallow section of South Street Cemetery. The evergreen trees that shade it have no doubt been the means of its preservation.

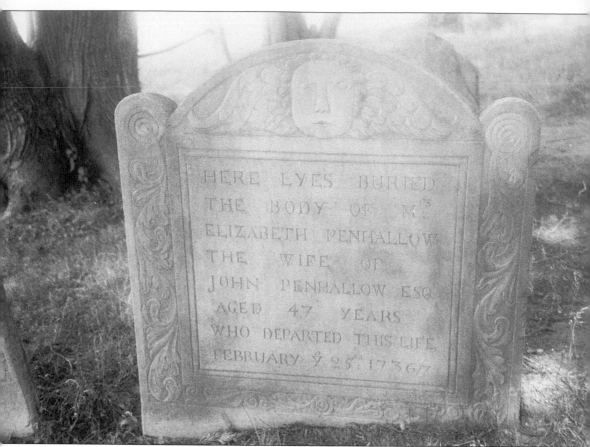

ELIZABETH PENHALLOW, 1736/37, SOUTH STREET, PORTSMOUTH. Nathaniel Emmes carved this unique stone, with its full-faced angel. Elizabeth married Capt. John Penhallow after 1717. She was the widow of John Watts, a Boston merchant who was a business partner of John Penhallow at Arrowsic, Maine, where he commanded the garrison. Elizabeth's maiden name was Butler, originally of Boston. She is buried in the Cutts-Penhallow portion of South Street Cemetery.

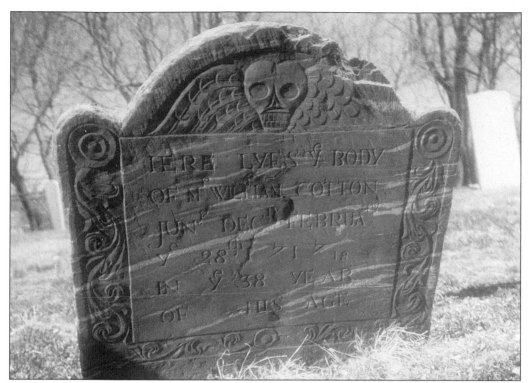

WILLIAM COTTON, 1717/18, SOUTH STREET, PORTSMOUTH. This winged skull gravestone was probably the work of Nathaniel Emmes. William Cotton was a tanner of Portsmouth and had four daughters and two sons.

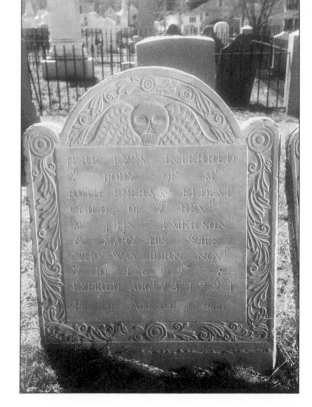

RUTH EMERSON, 1721, SOUTH STREET, PORTSMOUTH. Rev. John Emerson and his wife Mary had this stone carved in Boston for their oldest child, Ruth. Note the biblical inscription at the bottom of the stone, "And to die is gain."

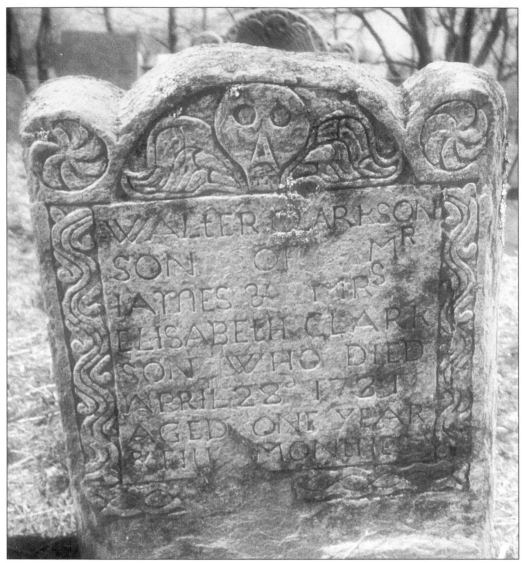

WALTER CLARKSON, 1739, SOUTH STREET, PORTSMOUTH. Stonecarver Robert Mullicken Jr. carved this gravestone in the Merrimac Valley style. Note the age of the deceased, only one year old. Walter's father, James Clarkson, was a man of distinction. He was born in Scotland and came to the colonies *c.* 1717 with his brother Andrew. He became a teacher in the public schools and boarded at the house of William Cotton (see prior page) and his wife, Elizabeth. From 1745 to 1765, James was the moderator of Portsmouth town meetings and occasionally served as a Representative.

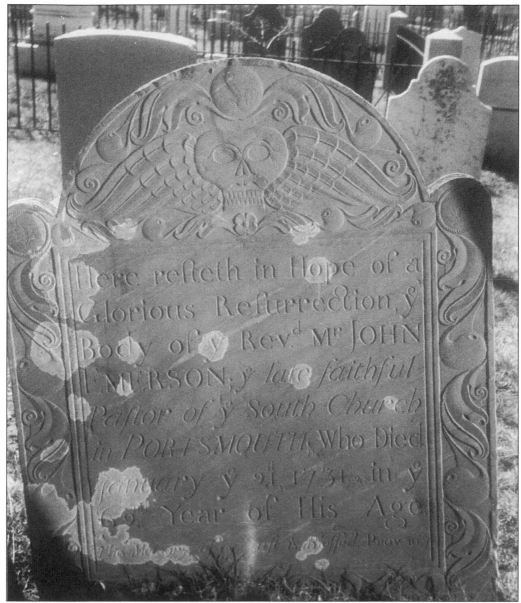

REV. JOHN EMERSON, 1731, SOUTH STREET, PORTSMOUTH. Rev. Emerson's elaborate gravestone, carved by the Lamson family, is indicative of the position he held in Portsmouth society. He was born in 1670 in Gloucester, Massachusetts, and graduated from Harvard in 1689. From 1704 to 1712, he was the minister at New Castle. During his service there, he visited London and caught the attention of Queen Anne. In 1715, Emerson became the first pastor of South Church. His final public service was a prayer of thanks after the raising of the new meetinghouse in 1731, later known as the Old South Meetinghouse. He is buried in the portion of South Street Cemetery known as Cotton's burial ground.

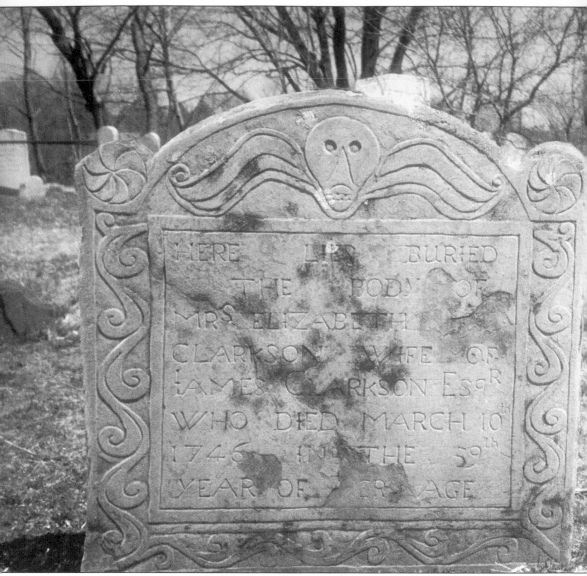

ELIZABETH CLARKSON, 1746, SOUTH STREET, PORTSMOUTH. The shape of the skull on this gravestone is the reason for its designation as a "pear" stone. Note the distinctive "W" in the inscription, carved by Joseph Mullicken, in the Merrimac Valley style. Elizabeth was the widow of William Cotton (see page 53). She married a younger James Clarkson, who had boarded with the Cottons after his arrival in the colonies from Scotland. Elizabeth inherited substantial property from her deceased husband, as well as a successful tanning business.

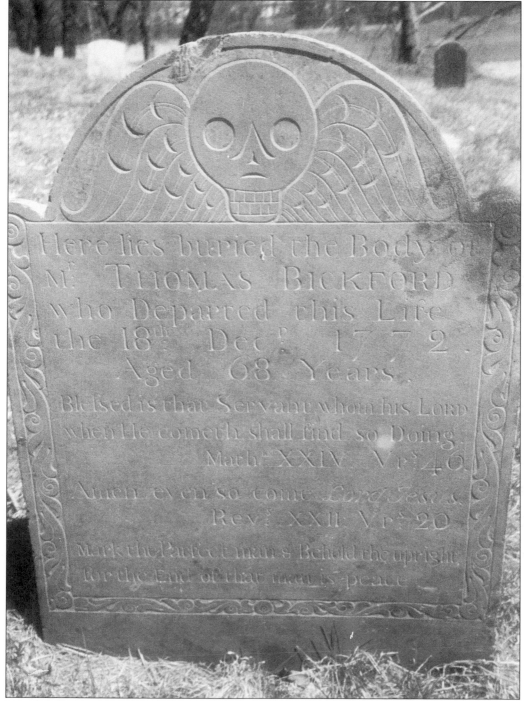

Thomas Bickford, 1772, South Street, Portsmouth. Although the tympanum is typical on this Boston-carved stone, the large amount of Biblical text found on it is unusual. Bickford was a schoolmaster of Portsmouth. He married Elizabeth Furber in 1727 and had eight children, six of whom survived him. Thomas Bickford's father, Henry, was a mariner and a weaver in Portsmouth.

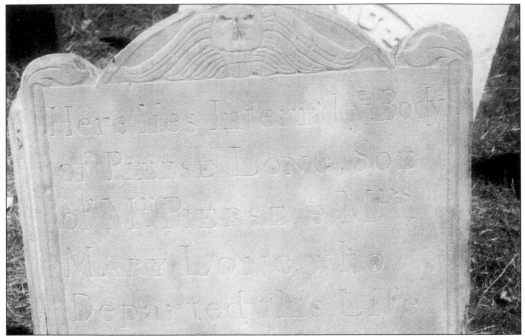

PIERSE LONG, 1769, SOUTH STREET, PORTSMOUTH. Note the menacing skull on this gravestone, carved by Henry Christian Geyer of Boston. Pierse Long's father, also Pierse, served in the Revolutionary War as a colonel in the New Hampshire militia. His regiment's successful retreat from Fort Ticonderoga in 1777 helped save the American army, allowing it to fight another day.

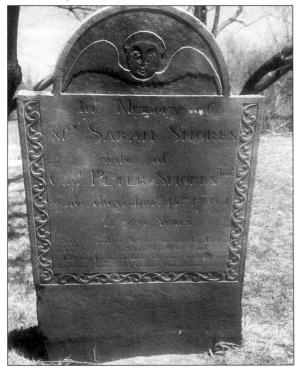

SARAH SHORES, 1791, SOUTH STREET, PORTSMOUTH. Sarah Shores's gravestone, with its lovely wide-eyed Angel, was the work of the Lamson family. Note the large expanse of unadorned stone at the bottom. This would have been underground originally, but has become exposed over the years.

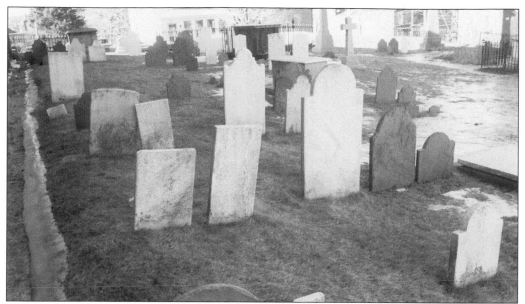

ST. JOHN'S CHURCHYARD, PORTSMOUTH. This picturesque Anglican churchyard sits on a hill overlooking Portsmouth harbor.

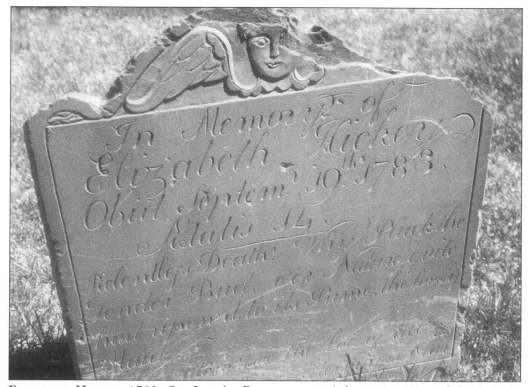

ELIZABETH HICKEY, 1783, ST. JOHN'S, PORTSMOUTH. A later generation of the Lamson family is responsible for this elegant work, carved for 14-year-old Elizabeth Hickey. Though damaged, the stone retains its delicate beauty.

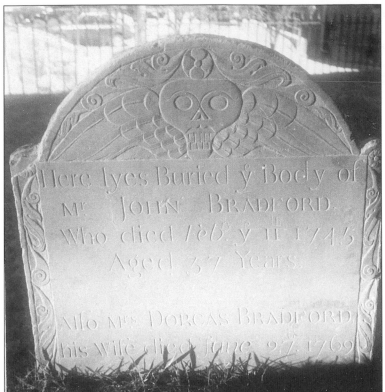

JOHN BRADFORD, 1745, AND DORCAS BRADFORD, 1769, ST. JOHN'S, PORTSMOUTH. The lines forming the nose curl up and over the eyes to form eyebrows; this design is typical of a skull carved by the Lamson family. John Bradford died in 1745, but this stone was not erected until Dorcas's death 24 years later.

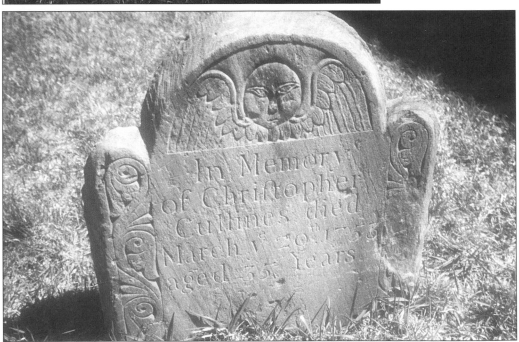

CHRISTOPHER CULLINES, 1753, ST. JOHN'S, PORTSMOUTH. This simple gravestone, with its round-faced, full-cheeked angel, was made by John Stevens of Newport, Rhode Island. Few Rhode Island-carved stones are found in the Seacoast area.

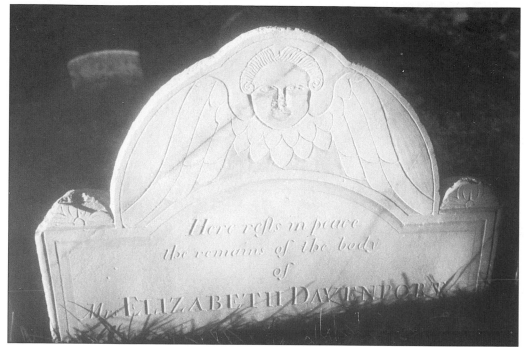

ELIZABETH DAVENPORT, ST. JOHN'S, PORTSMOUTH. Elizabeth Davenport's stone, by the Noyes family, has slowly sunk underground over the last 200 years or so, obscuring all of the inscription below her name. Note the detailed hair on the angel and the flowers on the shoulders of the gravestone.

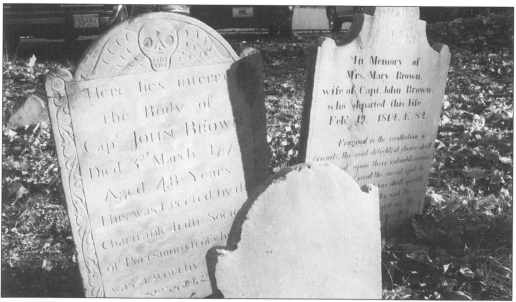

CAPT. JOHN BROWN, 1772, AND MARY BROWN, 1812, PLEASANT STREET, PORTSMOUTH. The 40 years between the deaths of this husband and wife saw significant changes in gravestone styles and motifs. John's stone has the winged skull, typical at the time of his death, while Mary's displays the later-used willow and urn. Note that John's gravestone was erected by the Charitable Irish Society, of which he was a "worthy member."

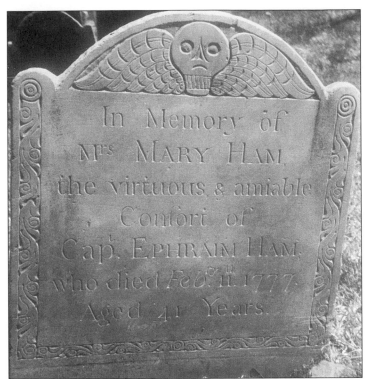

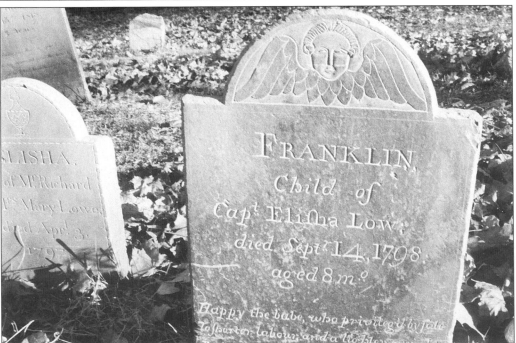

FRANKLIN LOW, 1798, PLEASANT STREET, PORTSMOUTH. Eight-month-old Franklin's stone was carved by the Noyes family. The small lettering at the bottom reads, "Happy the babe, who privileg'd by fate to shorter labour, and a lighter weight, Rece'v'd but yesterday the gift of breath, Order'd tomorrow to return to death."

Five

NEW CASTLE, ISLE OF SHOALS, RYE, AND GREENLAND

New Castle was originally part of Portsmouth and became an independent town in 1693. The first meetinghouse was built prior to 1706, while the current meetinghouse, the town's third, was built from 1828 through 1836. The small burial ground adjacent to the meetinghouse was likely established in the 1730s during the ministry of Rev. John Blunt.

The Isle of Shoals, discovered in 1614 by Capt. John Smith, was settled primarily by fishermen. The town of Gosport, on Star Island, was chartered in 1715. While there are several family burial grounds on the islands, the public burial ground is no longer extant. Due to the rocky nature of the soil, many of the island's dead were likely buried at sea. However, two of the town's ministers are buried on Star Island a short distance from the meetinghouse.

The town of Rye, settled by 1635, became independent in 1726. It was set off from parts of Portsmouth, Greenland, and New Castle. Remnants of the old town burial ground, established about this time, exist within the confines of the current town cemetery, near the site where the old town meetinghouses once stood.

Greenland, once a part of Portsmouth, became a separate town in 1703. However, it was not until July of 1706 that a church was organized here. Hillside Burying Ground is situated adjacent to the site of Greenland's first church.

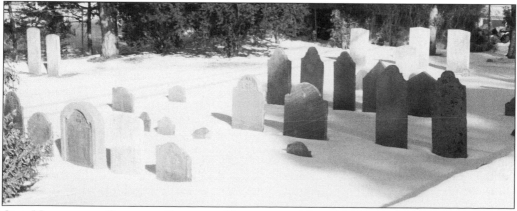

OLD NEWCASTLE BURYING GROUND, NEWCASTLE. The old Newcastle Burying Ground is across from the Congregational church.

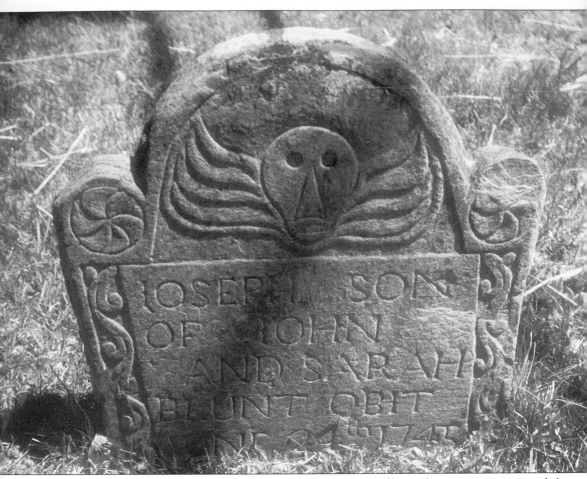

JOSEPH BLUNT, 1745, NEWCASTLE. This Merrimac Valley-style gravestone, carved by Joseph Mullicken, is sometimes referred to as a "pear" stone because of the shape of the skull. Note the deep, hollow eyes, and long, triangular nose, which adds to the skull's unearthly look. Joseph Blunt was the son of Rev. John Blunt, the minister of New Castle from 1732 until his death in 1748.

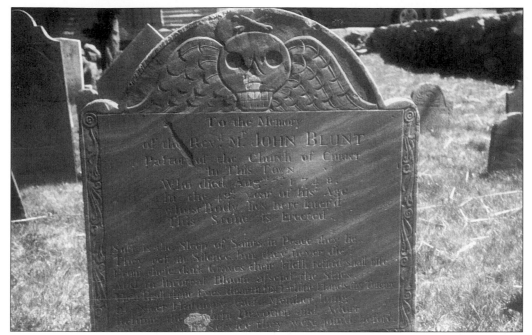

REV. JOHN BLUNT, 1748, NEWCASTLE. Rev. John Blunt, a 1727 Harvard graduate, came to Newcastle in 1732. On the day of his ordination, he married Sarah Frost, who was said to have "a good natural genius." She used her husband's library to further her own education, and had "a facility for writing good verse." The verse on John's stone is attributed to her.

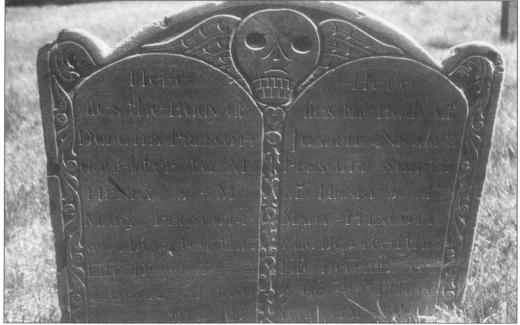

DORTHY PRESCOTT AND JOSEPH PRESCOTT, 1766, NEWCASTLE. The death of a child was all too common in colonial times. This dual stone marks the deaths of two- and three-year-old siblings, who died within a day of each other. Note the heart below the skull and the elaborate center border.

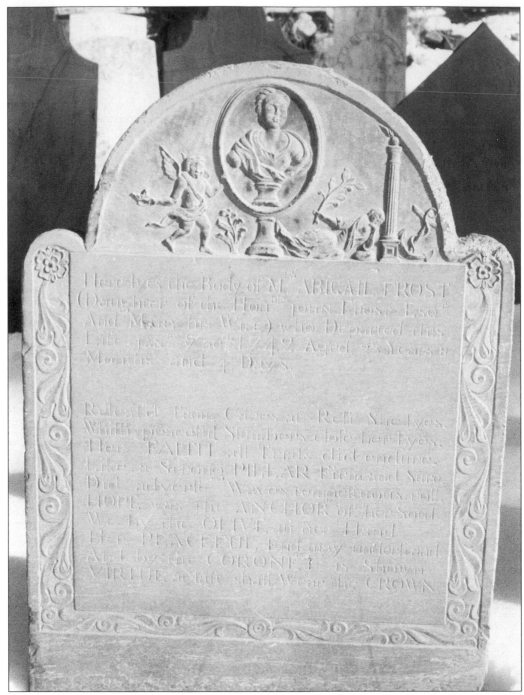

ABIGAIL FROST, 1742, NEWCASTLE. Probably the work of the Foster family of Dorchester, Massachusetts, this extravagantly carved stone is full of symbolism and is indicative of the Frost family's wealth. Abigail was the daughter of John Frost, who was a prominent Portsmouth mariner and commander of the British warship *Edward*. Abigail's mother was the former Mary Pepperell, the daughter of Colonel William Pepperell, and sister of Sir William Pepperell of Kittery.

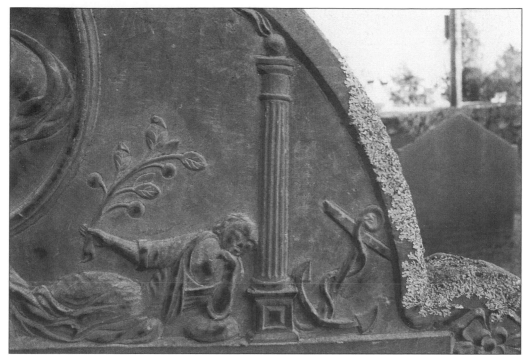

DETAILS FROM ABIGAIL FROST STONE, NEWCASTLE. Note the symbolic imagery, representing Abigail's character and her family's acceptance of her death. The inscription reads, in part, "Like a Strong PILLAR Firm and Sure . . . HOPE was the ANCHOR of her Soul . . . We by the OLIVE in her Hand, Her PEACEFUL End may understand . . . VIRTUE at last shall Wear the CROWN."

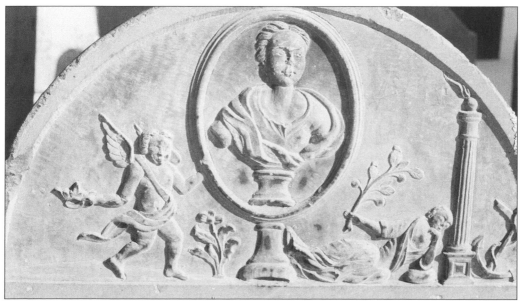

DETAIL FROM ABIGAIL FROST STONE, NEWCASTLE. The bust of a young woman is the central image on the tympanum. The face is intricately detailed and may be the likeness of young Abigail Frost. This portrait style catered to the upper class.

GOSPORT CHURCH, ISLE OF SHOALS. This second meetinghouse on Star Island was built in 1800, during the ministry of Rev. Josiah Stephens. It was partially destroyed by fire in 1826. The weathervane was added in 1859. The church has also served as a schoolhouse.

REV. JOSIAH STEPHENS, 1804, AND SUSANNAH STEPHENS, 1810, ISLE OF SHOALS. Rev. Stephens was ordained in 1800 as the isle's first pastor in 25 years. He was a native of Killingworth, Connecticut, and served in the Revolutionary War. His tablestone reads, in part, "a faithful instructor of youth and a pious minister of Jesus Christ. (Supported on this Island by the Society for Propagating the Gospel)."

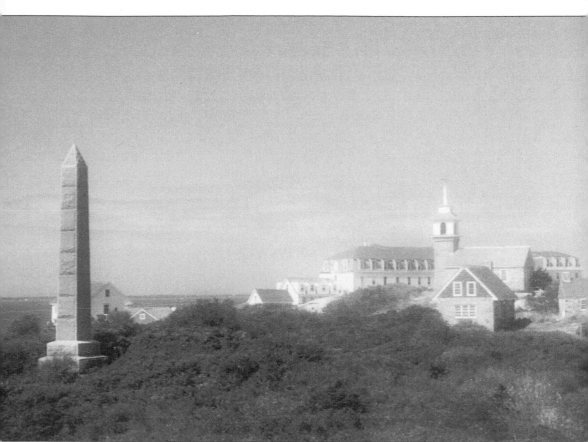

REV. JOHN TUCKE, 1773, ISLE OF SHOALS. The grave of Gosport Church's first minister is marked by this imposing obelisk. Tucke was a native of Hampton, New Hampshire, and a Harvard 1723 graduate. He accepted the call to preach on Star Island in 1732. His role was that of minister, teacher, doctor, and storekeeper. Rev. Tucke and his wife, Mary, had 11 children, seven of whom died young. Tucke died on August 12, 1773, after 41 years of service on the island. His descendants erected this monument in 1914, replacing an earlier one on the Island of Shoals. Its inscription, copied from his original gravestone, includes descriptions of the pastor from older people on the islands. The inscription from Tucke's monument reads, "He was affable and Polite in his manner, Amiable in his Disposition, of Great Piety and Intellect, given to Hospitality, Diligent and faithful in His Pastoral office, well learned in History and Geography, as well as General Science and a careful Physician Both to the Bodies and the Souls of his People."

JOSEPH PHILBRICK, 1755, RYE. Note the swirling side borders and unique angel, with its round face, wide eyes, and ample lips, on this Merrimack Valley-style gravestone. It is probably the work of Jonathan Leighton. Joseph Philbrick was a mariner of Hampton, and later, Rye. He married Tryphana Marston prior to December 1686.

TRYPHANA PHILBRICK, 1729, RYE. Many unusual colonial names are found on surviving gravestones. Tryphana was the daughter of Capt. William Marston. When he died in 1672, he left everything to eight-year-old Tryphana, to the dismay of his son William, who fought for control of the family homestead and eventually won his case in court.

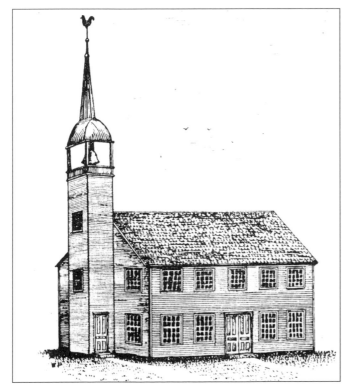

THE FIRST MEETINGHOUSE, 1725, RYE. This picture originates from an illustration in *History of the Town of Rye, New Hampshire*, by Langdon Parsons. The meetinghouse was built in 1725, but not finished until 1729. It was torn down and replaced in 1755. The oldest gravestones found in Rye are remnants of the burial ground that was adjacent to this meetinghouse.

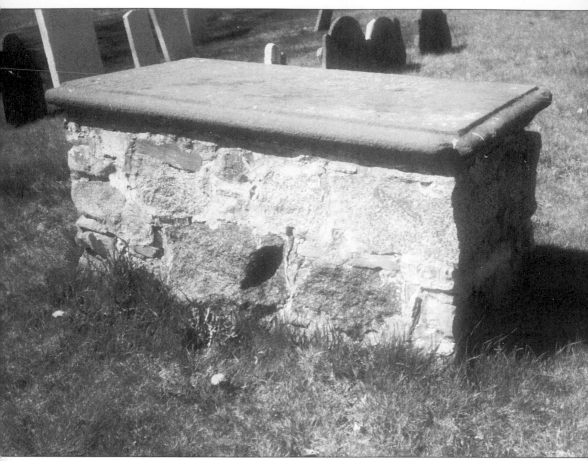

ELIZABETH PACKER, 1717, GREENLAND. Elizabeth Packer's tablestone is one of relatively few that remains in the Seacoast area. While the base is much newer, the red sandstone top is original. The former Elizabeth Smith was originally of England and came to the area at the request of her uncle, Major Richard Waldron of Dover. She married Joseph Hall of Greenland. After Hall died in 1685 from small pox, Elizabeth married Thomas Packer, in 1687. Her tablestone is indicative of the Packers' wealth and social status.

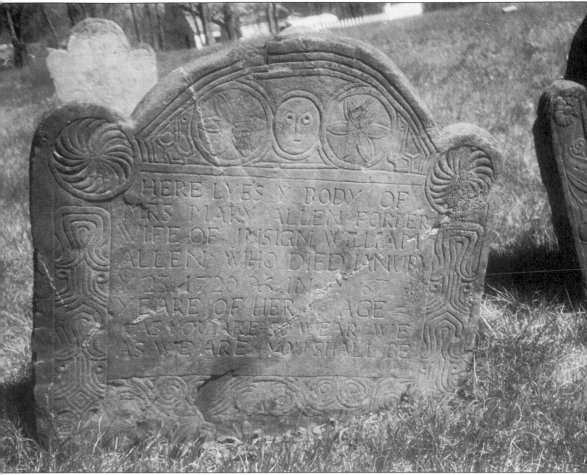

MARY ALLEN, 1720, GREENLAND. This Merrimack Valley-style gravestone was carved by the originator of the style, John Hartshorne. His unusual designs, unlike any ever seen in gravestone art before, make Hartshorne one of America's first folk artists. Note the acanthus leaves and birds with upturned beaks in the corners of the tympanum. Mary Allen was probably the mother of Greenland's Rev. William Allen. Her inscription reads, in part, "AS YOU ARE, SO WEAR WE, AS WE ARE, YOU SHALL BE."

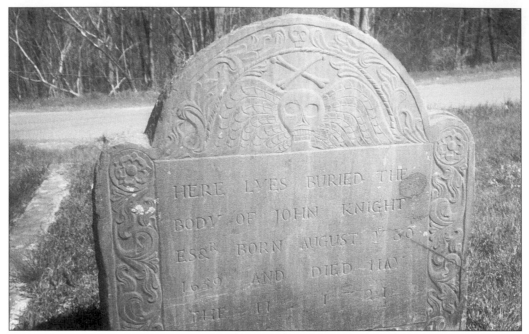

JOHN KNIGHT, 1721, GREENLAND. John Knight was from the Isle of Jersey and came to Portsmouth by 1681. He married the former Bridget Sloper of Portsmouth on March 29, 1684. He owned much property in Portsmouth and Newington, including the Hilton Point-Kittery Ferry.

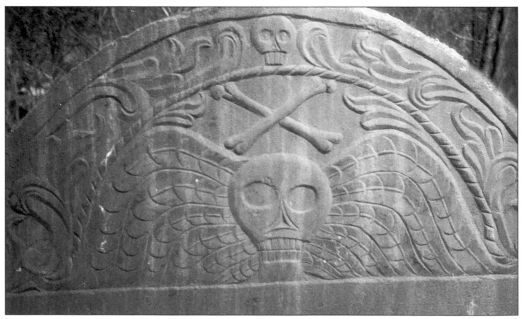

DETAIL, JOHN KNIGHT GRAVESTONE, GREENLAND. John Knight's elaborate stone is a Boston area work, possibly that of Nathaniel Emmes. Note the small skull over the larger one, with the crossbones in between.

ELEANOR ALLEN, 1735, GREENLAND. The Lamson family is responsible for this striking stone. Eleanor was the wife of Greenland's first minister, Rev. William Allen, whom she married c. 1710. "She was good and faithful in every relation, contented in every state and condition, harmless and blameless . . . Twenty and five years she lived in perfect peace and sweet Amity with her worthy Yoke-fellow . . ."

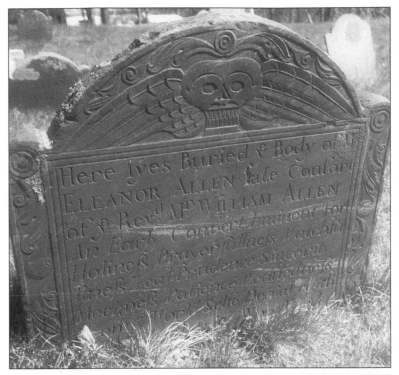

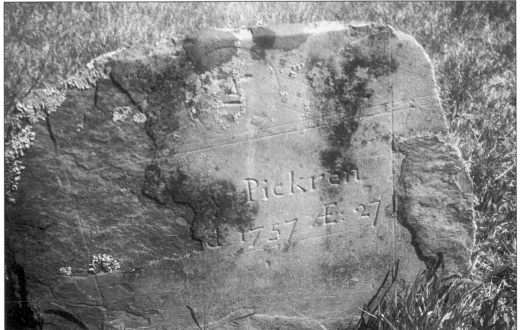

THOMAS PICKREN, 1757, GREENLAND. The design on this stone, with its round face from which thin lines emanate, is unusual. It may be home carved or the work of an unknown stonecarver. Thomas Pickren was the son of the Thomas Pickering who was killed, c. 1746, in battle at the Fort Annapolis in Nova Scotia during a French assault. Thomas Jr. was baptized at South Church, Portsmouth, in 1730/31.

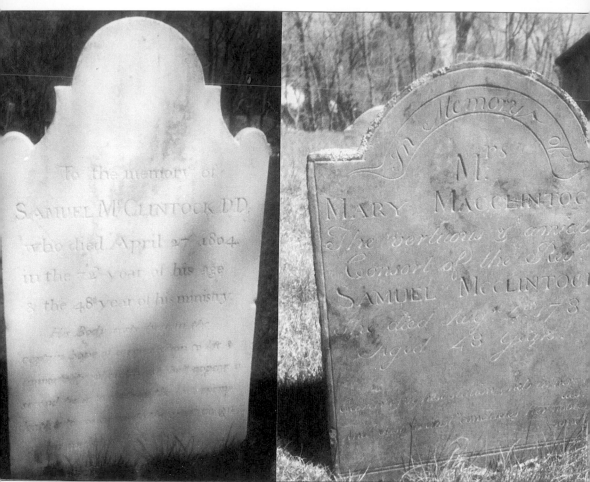

SAMUEL MCCLINTOCK, 1804, AND MARY MACCLINTOCK, 1785, GREENLAND. Samuel McClintock was born in 1732 to Scotch emigrant parents in Medford, Massachusetts. He graduated from the College of New Jersey, later known as Princeton, in 1751, after which he preached in various central New Hampshire towns. He was ordained as a colleague of Greenland's Rev. William Allen in 1756. McClintock was active in the French and Indian War as a chaplain. He also served as a chaplain in the Revolutionary War. McClintock was a school keeper, a proprietor of the social library, and Greenland's leading citizen. He only missed one Sabbath service during his 48-year ministry, the last of his life. The former Mary Montgomery, a "Scotch lass," married Samuel in 1754. They had 15 children, three of whom were killed in the Revolutionary War.

Six

STRATHAM AND EXETER

Stratham, originally part of Exeter, became an independent town in 1716. The first meetinghouse was built in 1718 on land Daniel Leavitt gave to the town. In return for having the church built in the more northerly part of town, closer to them and away from the majority of the inhabitants, Andrew and Simon Wiggin gave the town land for the parsonage farm. The burial ground, likely established at this same time, was not extensively used because most families used private burial plots closer to home.

Exeter was first settled in 1638 on land purchased from the "Indians" by Rev. John Wheelwright. Exeter's oldest remaining burying ground is the Thing Burying Ground, located on a knoll above the Squamscott River off Green Street. The second oldest burial ground is adjacent to the Congregational Church on Front Street. This site was first used c. 1696 when the first meetinghouse on this site was built. The burying ground was originally much more extensive, but, prior to 1876, most of the gravestones were deliberately buried and leveled with the ground when Front Street was widened. Sources say that the gravestones were not destroyed or removed "so that, should occasion require, the information they contain can at any time hereafter be made available."

Col. John Gilman deeded the Front Street Burying Ground to the town in 1742, though it had previously been used for the Gilman family. It fell into gradual disuse after the opening of the new town cemetery in 1844.

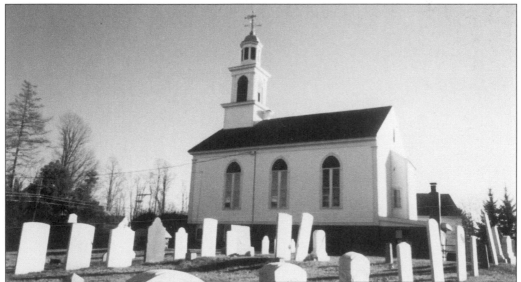

CONGREGATIONAL MEETINGHOUSE AND BURIAL GROUND, STRATHAM. Built in 1837, the Congregational meetinghouse in this photograph is the third such structure in Stratham's history.

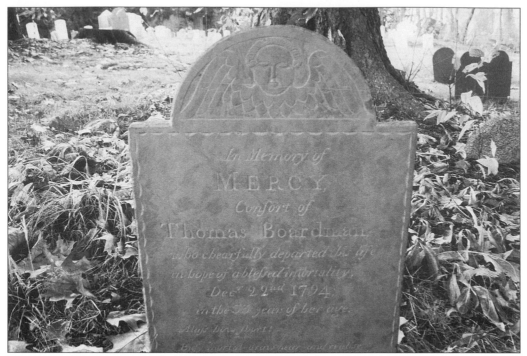

MERCY BOARDMAN, 1794, STRATHAM. Life was fragile, even this late in the 18th century. The Noyes family carved this pair of stones for mother and infant daughter (see photograph below). Mercy died within months of Betty, possibly due to the effects of childbirth.

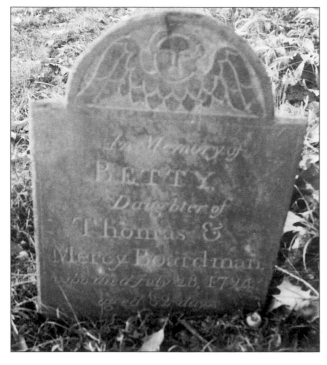

BETTY BOARDMAN, 1794, STRATHAM. Betty's father, Thomas Boardman, was a deacon of the Stratham Church.

MARY LANE, 1769, STRATHAM. Mary, born March 3, 1722, was the daughter of Hampton weaver Benjamin James. She married Samuel Lane of Hampton on December 24, 1741, and, soon after, moved to Stratham. She died in 1769, at the age of 47. Her gravestone was likely carved in 1806, at the same time as that of her husband, Samuel, based on its more "modern" design.

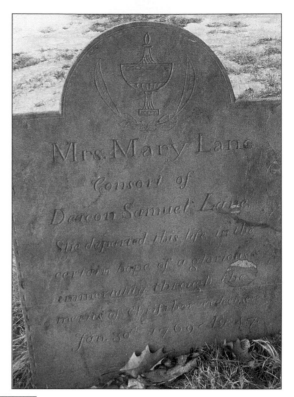

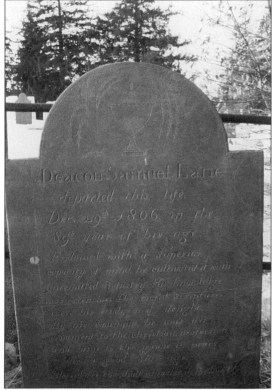

DEACON SAMUEL LANE, 1806, STRATHAM. Samuel was the eldest son of Deacon Joshua Lane of Hampton and brother of Jeremiah Lane. He became one of Stratham's most prominent citizens, practicing the trades of tanner, cordwainer, and public surveyor. A well-read man, Samuel Lane was said to have had the second largest library in town. He also kept an extensive diary, which details many of his everyday activities.

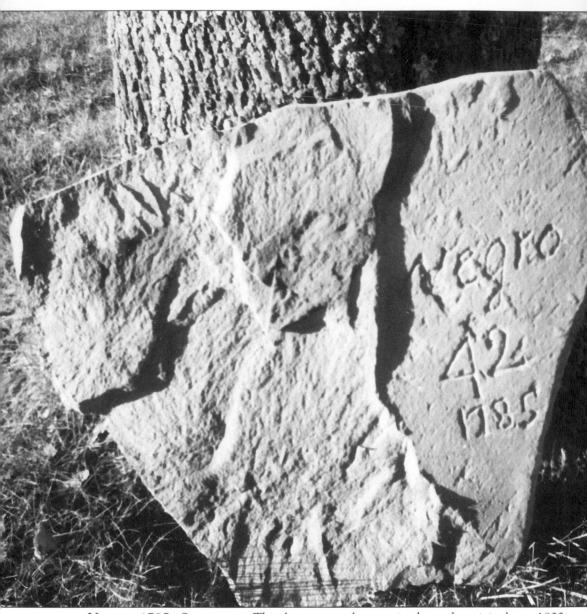

_____ NEGRO, 1785, STRATHAM. This home-carved stone is the only original pre-1800 gravestone for an African American in the Seacoast area. It was carved for former Capt. George March's slave Caesar Wood, born in 1743. In 1773, Wood was one of four slaves in Stratham. Wood enlisted in the Continental Army on May 2, 1781, for three years, at the end of the American Revolution. He returned to Stratham as a free man, but died shortly thereafter. He was buried in the Robinson family's private graveyard. He must have been held in high esteem, as an inscribed gravestone was a tribute rarely given to former slaves. This unique stone was, at some point, removed from the private graveyard, and spent many years propped up against the foundation of the Robinson-Brackett house on Depot Road. When the house was auctioned off, the stone was sold separately and ended up in the hands of a Seacoast antique dealer. Graeme Mann tracked it down and purchased it on behalf of the Stratham Historical Society, where it resides today.

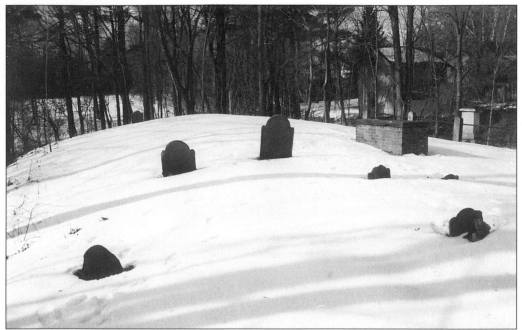

THE THING BURIAL GROUND, EXETER. The Thing Burial Ground was used primarily by members of the Dudley, Thing, and Ladd families. The brick tomb, to the right in this photograph, belongs to Rev. Samuel Dudley, who came to Exeter in 1650, and preached here until his death on February 10, 1683.

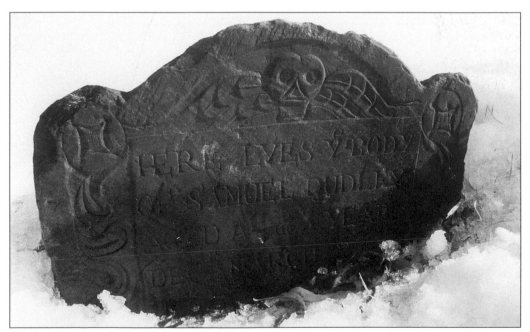

SAMUEL DUDLEY, 1718, THING BURIAL GROUND, EXETER. Samuel Dudley was the son of Samuel and Hannah (Colcord) Dudley and the great-grandson of Rev. Samuel Dudley.

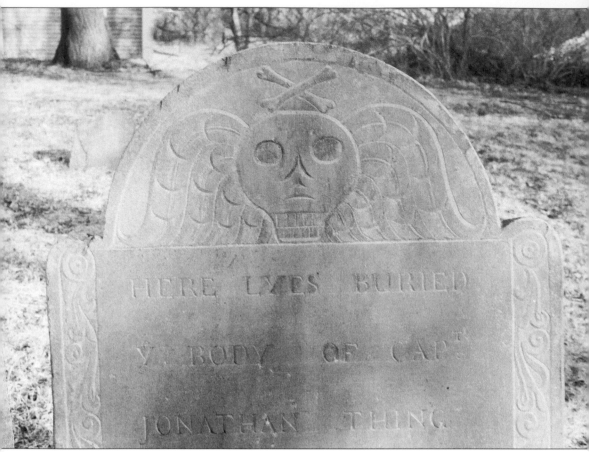

DETAIL OF CAPT. JONATHAN THING STONE, 1694, THING BURIAL GROUND, EXETER. Capt. Thing's father, Jonathan Sr., came to Exeter by 1659, where he became a prominent citizen. This was despite the fact that, when a young man, in 1641, he was sentenced to be whipped in Boston for "ravishing" Mary Greenfield. Captain Thing was a town clerk and constable. He died on October 31, 1694, when he was shot by his own gun as he fell from his horse. His gravestone, although dated 1694, is backdated, and is of a style carved in the 1730s, possibly by James Foster II.

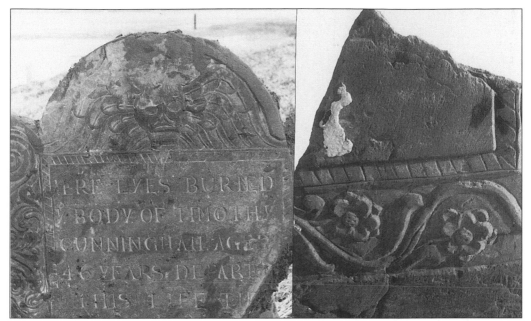

TIMOTHY CUNNINGHAM, 1712, THING BURIAL GROUND, EXETER. This fragmented gravestone is for a shopkeeper of Boston who came to an untimely death far from home. He was shot down and killed by a party of "Indians" on April 16, 1712, at four o'clock in the afternoon, while traveling to Exeter from Hilton's Garrison. He left a wife, four children, and "respectable property" in Boston.

ABIGAIL THING, 1711, THING BURIAL GROUND, EXETER. Abigail, born in 1686, was the daughter of Tristram and Deborah Coffin of Exeter. She married Bartholomew Thing, son of Capt. Jonathan Thing, on December 7, 1705. Abigail's gravestone was carved by Joseph Lamson. Note how the lines on the nose of the skull cross up and over to form its eyebrows.

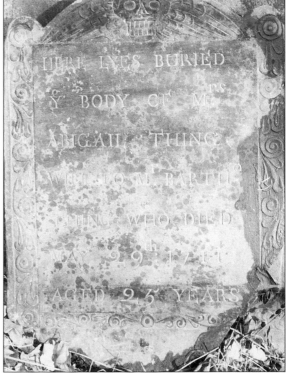

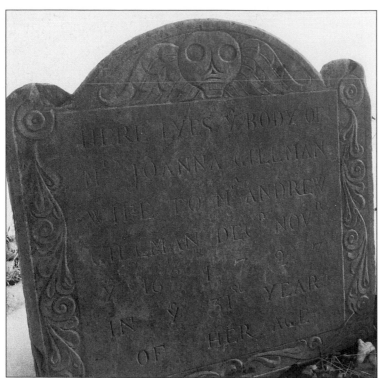

Joanna Gillman, 1727, Thing Burial Ground, Exeter. Joanna was the daughter of Samuel Thing, a blacksmith of Exeter. She was born on June 22, 1697, and married Andrew Gillman on January 27, 1714/15. Andrew, the son of Capt. Jeremiah Gilman, was taken captive by "Indians" and held in Canada in 1710/11.

Abigail Ladd, 1747, Thing Burial Ground, Exeter. Abigail was probably the former Abigail Webster, later married to Stephen Ladd. This stone was home carved.

CONGREGATIONAL CHURCH, EXETER.
The Congregational church on Front
Street was built in 1798 by James Folsom
following plans by Ebenezer Clifford and
Bradbury Johnson. It is the fifth
Congregational church structure erected
in Exeter.

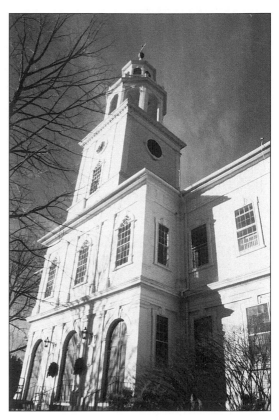

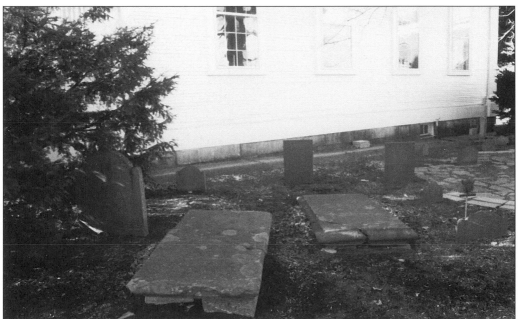

CONGREGATIONAL CHURCH BURIAL GROUND, EXETER. This burial ground was established in
the late 1690s, when the first meetinghouse on this site was built. The sidewalk around the
church, as well as the road, pass over portions of the original burying ground.

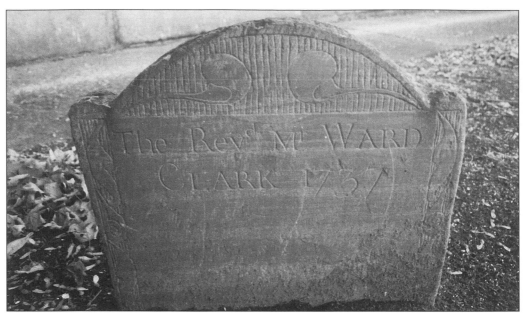

FOOTSTONE, REV. WARD CLARK, 1737, CONGREGATIONAL CHURCH BURIAL GROUND, EXETER. Ward Clark was the son of John Clark, Exeter's third minister. He graduated from Harvard in 1723 and, shortly thereafter, went to Kingston. He was minister there during the time that the Throat Distemper epidemic struck in 1735.

DETAIL, REV. WARD CLARK, 1737, CONGREGATIONAL CHURCH BURIAL GROUND, EXETER. The epitaph on his Lamson-carved gravestone encapsulated his life. "Here lyes what was mortal of The Revd Mr. Ward Clark, late pastor of a church at Kingston, where he was ordained Sept 29, 1723. He was the youngest son of the Revd Mr. John Clark of Exeter, whose ashes lay hard by this tomb . . . He buried His wife & children in a time of great mortality not long before his own Decease."

FRONT STREET BURIAL GROUND, EXETER. Seldom used after 1844, this burial ground is in poor condition due to years of vandalism and neglect.

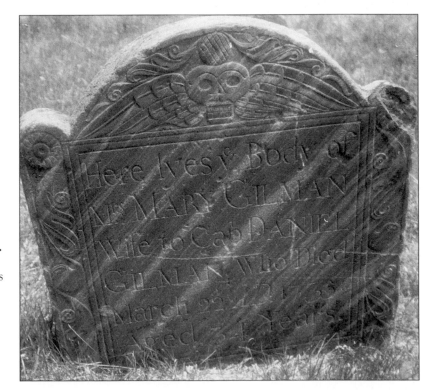

MARY GILMAN, 1735, FRONT STREET, EXETER. The Lamson family carved this stone, one of the oldest remaining in this burial ground. Mary Gilman was the wife of Capt. Daniel Gilman.

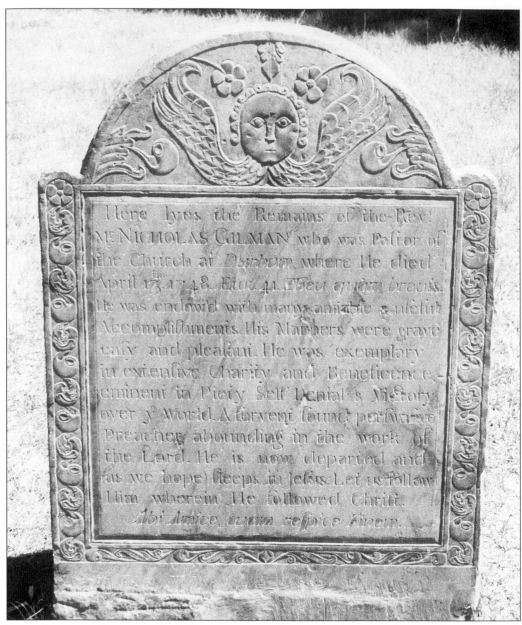

REV. NICHOLAS GILMAN, 1748, FRONT STREET, EXETER. Gilman was born in Exeter in 1708. He graduated from Harvard in 1724, after which he taught school in Stratham. He first preached in Kingston in 1727, then in Portsmouth and Newmarket. In 1730, he married Mary Thing and came back to Exeter as a schoolteacher. In 1736 and 1737, he was again preaching at Kingston as a substitute for the dying Ward Clark. He was hired by the Durham church as its minister in 1742. The Great Awakening hit Durham in full force, throwing the church into an uproar. Gilman's fiery preaching gave him fame as the wildest of New England's New-Light preachers. After a time, Gilman withdrew from his church, taking with him his fanatical followers, referred to as the "Durham Dancers." It is said that his death was hastened by his habit of spending the night in the cold, wet woods praying. The young men of Durham carried Gilman to his final resting-place in Exeter.

Seven

NORTH HAMPTON, HAMPTON, AND HAMPTON FALLS

Originally a part of Hampton, North Hampton separated, in 1738, and became known as the North Hill parish. The old burial ground on Post Road is within the grounds of the current town cemetery and dates to 1734, about the same time the first meetinghouse was built a short distance away. The oldest remaining gravestone here is dated 1736.

Hampton, one of New Hampshire's four original towns, was settled in 1638 by followers of Rev. Steven Bachiler under a grant from the Massachusetts Bay Colony. Pine Grove Burying Ground was laid out prior to 1654 and lies on what was once the eastern part of the meetinghouse green. It was used by the town for nearly 150 years until Ring Swamp Cemetery was established in 1797. Pine Grove contains works by some of the finest stonecarvers from Boston and the Merrimack Valley region.

Hampton Falls, originally part of Hampton, was the South Parish of Hampton in 1710. In 1718, the town became independent. The first meetinghouse was built in 1711, while the "Old Burying Ground," adjacent to that site, was laid out in 1704 by Capt. Jacob Green and Lt. Joseph Swett. The town's second burial ground, on Nason Road, was established in December 1781 on a half acre of land bought from Jeremiah Lane for $15. It is near the site of the town's second meetinghouse, built in 1770.

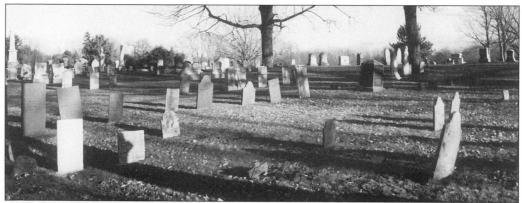

POST ROAD BURIAL GROUND, NORTH HAMPTON. This view is of an older portion of the Post Road Burial Ground in North Hampton.

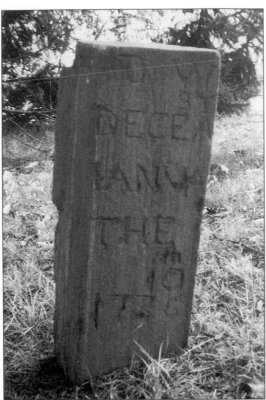

O.W., 1736, NORTH HAMPTON. The oldest gravestone found in the Post Road burial ground, this simple home-carved stone, shaped as a post, dates to January 1736. The deceased probably died during the Throat Distemper epidemic, which claimed 49 lives from all Hampton parishes in December 1735 alone.

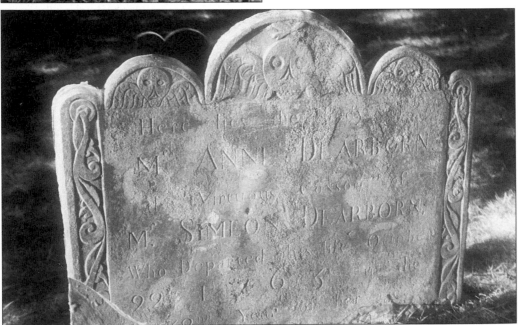

ANNE DEARBORN, 1763, NORTH HAMPTON. James Foster II probably carved this striking tripartite headstone, with its three winged skulls. Anne Dearborn was the "virtuous consort" of Simeon Dearborn, one of the members of this family, whose roots in North Hampton date back to at least 1667.

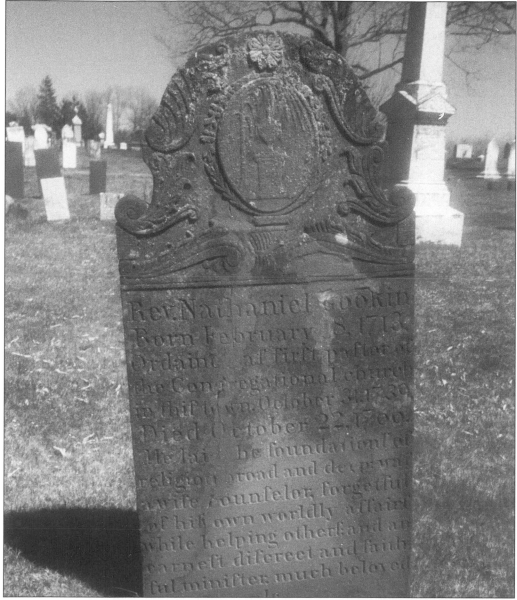

REV. NATHANIEL GOOKIN, 1766, NORTH HAMPTON. Gookin, the first minister of North Hampton, came from a long line of distinguished ministers. He was born February 6, 1713, the son of Rev. Nathaniel Gookin of Hampton. His grandfather John Cotton and great-grandfather Seaborn Cotton were both ministers of Hampton. Gookin graduated from Harvard in 1731 and, after preaching in Haverhill and Chelmsford, Massachusetts, was ordained in North Hampton on October 31, 1739. An unassuming man, he suffered financial hardship despite his wealthy family ties. Though not involved in the larger affairs of church and state, Reverend Gookin was admired by his colleagues and members of his parish. He died of apoplexy on October 22, 1766. His obituary in the *New Hampshire Gazette* reads, in part, "His judgement was solid and penetrating—for my own part, there were few, if any, I should sooner have applied to for advice in any difficult affair; You had his opinion in a few words, directly to the point and always judicious."

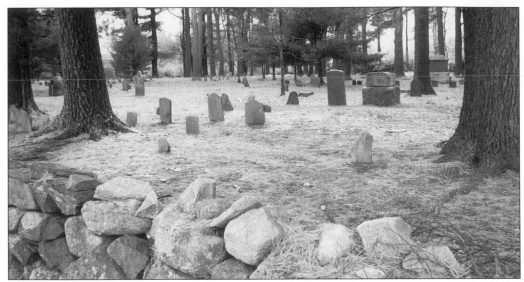

PINE GROVE BURIAL GROUND, HAMPTON. Laid out in the early 1650s, this is one of the oldest remaining burial grounds in the entire state.

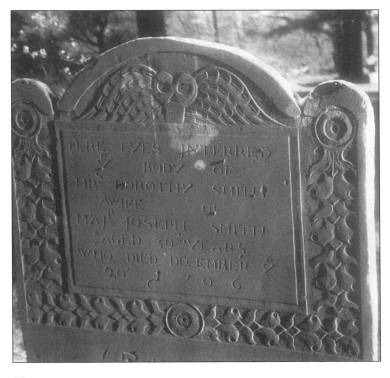

DOROTHY SMITH, 1706, PINE GROVE, HAMPTON. Note the elaborate border and foreboding skull on this stone, possibly the work of Joseph Lamson. Dorothy was the daughter of Rev. Seaborn Cotton, Hampton's third minister, and his wife Sarah, the daughter of Governor Simon and Anne Dudley, a poetess. Mrs. Smith was born November 11, 1656, in Hartford, Connecticut, while her father was preaching in nearby Windsor. She married Joseph Smith, a prominent Hampton citizen, prior to 1694.

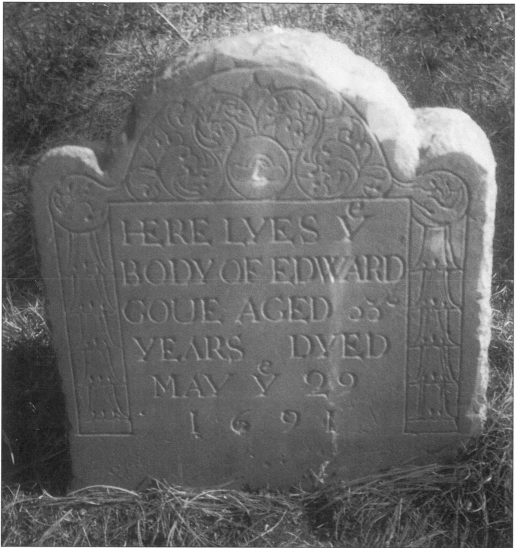

EDWARD GOVE, 1691, PINE GROVE, HAMPTON. Gove and his wife Hannah first came to Hampton in 1665. He is remembered for his insurrection against New Hampshire's Royal Governor Edward Cranfield in January 1683. A wealthy and popular man, Gove was disturbed at the Cranfield's abuse of power when he dissolved the New Hampshire Assembly, of which Gove was a member. Fearing a loss of civil liberties, Gove declared "that his sword was drawn, and he would not lay it down, till he knew who should hold the government." Gove and his small group of followers were arrested by the militia and taken in irons from Hampton to Portsmouth, where the nine men were put on trial for treason. Gove alone was found guilty and was sentenced to be hanged, drawn, and quartered, and his body to be "disposed of at the king's pleasure." Gove was sent to England and imprisoned for three years, until he was given a reprieve and returned home. He is one of the few men imprisoned in the Tower of London who lived to tell about it.

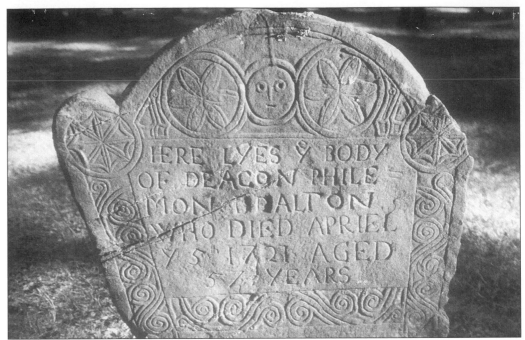

PHILEMON DALTON, 1721, PINE GROVE, HAMPTON. John Hartshorne carved this Merrimack Valley-style stone. Note the unusual spelling of the month "Apriel." Dalton, the son of Samuel and Mehitable Dalton, was born on December 15, 1664. In 1683, Philemon Dalton was taxed as a resident of Hampton and, in 1686, was town constable. He married the former Abigail Gove in 1690 and named eight children in his will. Abigail was the daughter of the revolutionary Edward Gove.

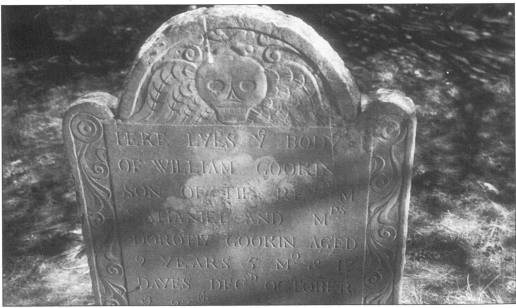

WILLIAM GOOKIN, 1723, PINE GROVE, HAMPTON. William was the young son of Rev. Nathaniel and Dorothy (Cotton) Gookin. Reverend Gookin was one of Hampton's most popular ministers, serving the town from 1710 until his death in 1734.

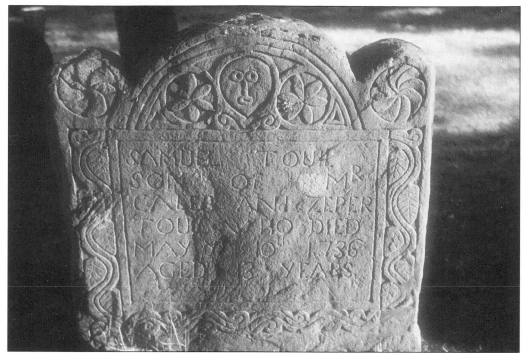

SAMUEL TOWLE, 1736, PINE GROVE, HAMPTON. Note the detail on the leaves in the side borders of this Joseph Mullicken gravestone. Samuel's mother, Zipporah, was the daughter of Capt. Anthony Brackett, who was active in King Phillips War, helping to build a garrison on the Kennebec River. Samuel Towle was born in September 1722. He was very likely a victim of the Throat Distemper epidemic.

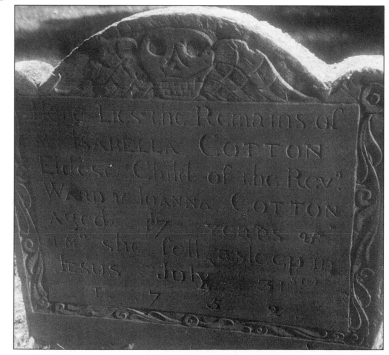

ISABELLA COTTON, 1752, PINE GROVE, HAMPTON. Isabella was the oldest child of Rev. Ward Cotton and his wife Joanna. Reverend Cotton, a 1729 Harvard graduate, succeeded Rev. Nathaniel Gookin as minister in Hampton in 1734. Reverend Cotton was dismissed in 1765 due to "a paralytic shock which impaired his moral judgment," and he died in 1768 at Plymouth, Massachusetts. Joanna married four more times after Ward's death.

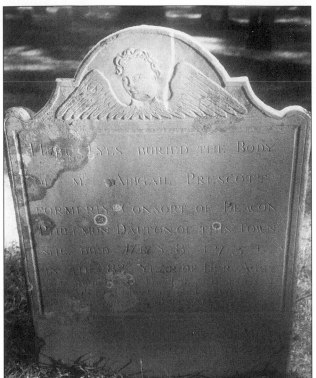

ABIGAIL PRESCOTT, 1751, PINE GROVE, HAMPTON. The striking, side-looking angel on this stone was carved by Henry Emmes. Note the reference to Abigail's first husband, Deacon Philemon Dalton, in the epitaph, without mention of her later husbands. After Dalton's death in 1721, Abigail married Deacon Benjamin Sanborn, in November 1724; he died in December 1740. She married James Prescott, a sergeant and deacon of Hampton Falls, in June 1746.

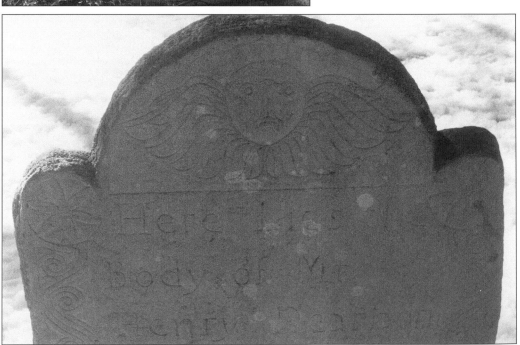

HENRY DEARBORN, 1756, PINE GROVE, HAMPTON. Dearborn's gravestone, with its unusual angel, was carved by Jonathan Leighton. Henry, born in 1688, married the former Hannah Dow in October 1708 and had five children with her. Dearborn was a selectman of Hampton and "fell dead in the road" on April 26, 1756.

MARY MOULTON, 1753, PINE GROVE, HAMPTON. Note the curled locks of hair on the hollow-eyed angel, which decorates this Joseph Mullicken stone. Young Mary, baptized in March 1751, was one of Capt. Josiah and Abigail Moulton's six children. All of their children died in childhood, five of them from a recurrence of the Throat Distemper epidemic.

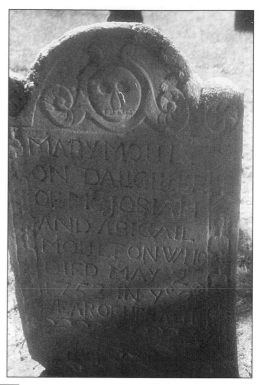

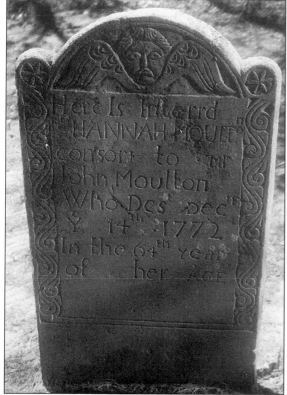

HANNAH MOULTON, 1772, PINE GROVE, HAMPTON. Hannah Moulton's well-preserved stone was carved by Jonathan Hartshorne. The frowning face with thick lips is typical of his work. Hannah was the daughter of Benjamin Lamprey. She married John Moulton in February 1734; they had eight children. Her youngest son, Simon, died on September 5, 1775, while serving in the Continental Army at Medford, Massachusetts.

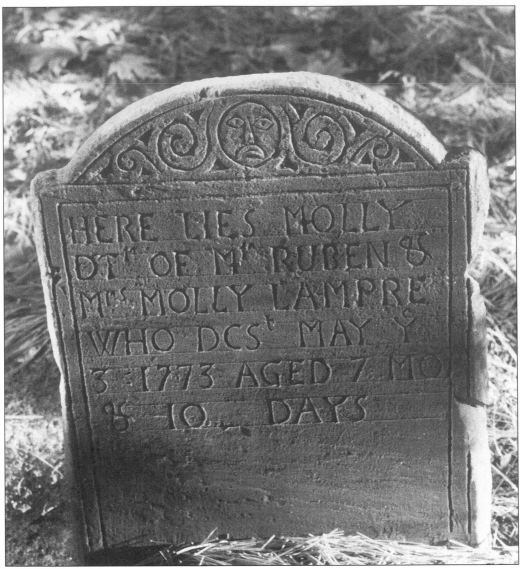

MOLLY LAMPREY, 1773, PINE GROVE, HAMPTON. This diminutive gravestone is the work of Jonathan Hartshorne. While it has his trademark face, the usual wings were replaced by scrolls. Note how the carver ruled the stone to keep the lettering straight. Molly was the first child of Reuben Lamprey and his wife, Molly, who was his cousin and daughter of Henry Lamprey. Mrs. Lamprey died on September 10, 1772, 18 days after daughter Molly's birth. Reuben Lamprey married the former Sarah Marston, on June 3, 1773, just one month after his daughter's death and 8 months after the death of his first wife. It was not uncommon in the 18th century to remarry quickly.

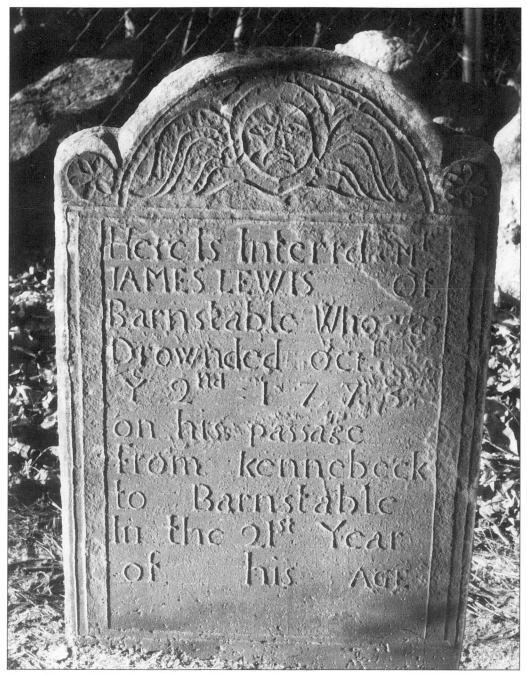

JAMES LEWIS, 1773, PINE GROVE, HAMPTON. Lewis's gravestone occupies a lonely spot in Pine Grove, in the far left corner of the burial ground. It was carved by Jonathan Hartshorne. The epitaph gives details of his untimely death far from home.

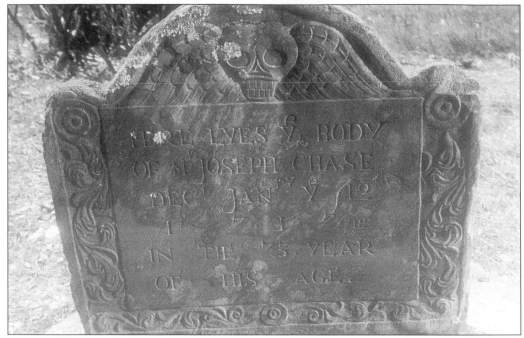

JOSEPH CHASE, 1717/18, LANDING BURIAL GROUND, HAMPTON. Chase, like his father, Thomas, and uncle Aquila, was a master of a coasting vessel and was referred to as "Goodman Chase of Hampton, boatman." His only son, Jonathan, drowned in 1696 at Currituck Inlet, in present-day North Carolina, probably as a seaman on a coasting vessel. Chase became a Quaker later in life, while his wife did not. His brother, Thomas, was a Quaker preacher.

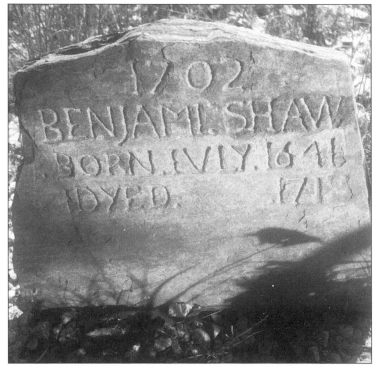

BENJAMIN SHAW, 1718, SHAW BURIAL GROUND, HAMPTON. Benjamin, the son of Roger Shaw who first came to Hampton in 1647, was born July 16, 1646, possibly in Cambridge, Massachusetts. He became a trader, and married the former Esther Richardson in May 1663. They lived on his father's homestead, and had 12 children. It is not known why the date 1702 is carved at the top of this homemade gravestone.

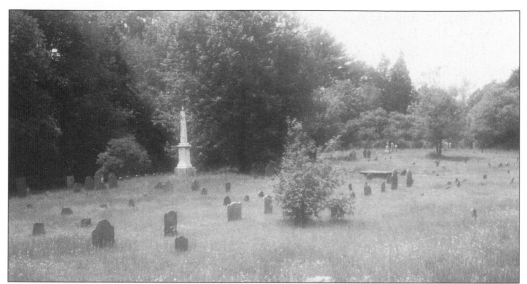

"OLD BURYING-GROUND," HAMPTON FALLS. Despite the fact that it is close to Route I-95, this burial ground looks much like it did 200 years ago.

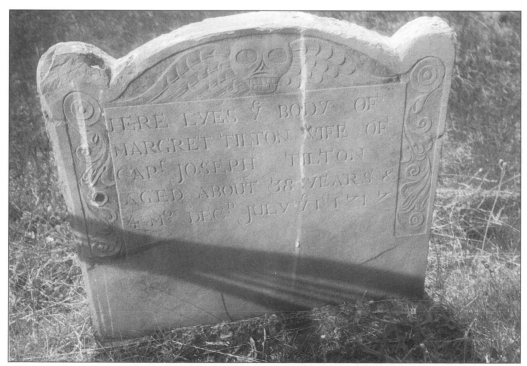

MARGRET TILTON, 1717, HAMPTON FALLS. Margaret was the daughter of Capt. Samuel Sherburne, who owned a private ferry and bought the Old Tuck Inn in Hampton in 1678. Samuel, a militia captain, was killed by "Indians" at Casco Bay, Maine, in 1691. Margret married Capt. Joseph Tilton on December 26, 1698.

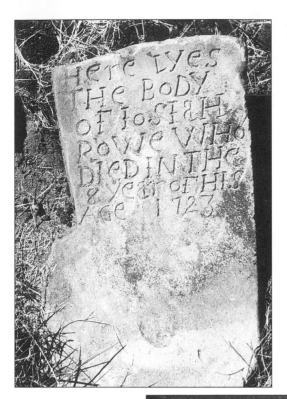

JOSIAH ROWE, 1723, HAMPTON FALLS.
This home-carved stone remains as legible today as it was over 275 years ago. Young Josiah was the son of Robert and Mehetable (Leavitt) Rowe. He was born on February 25, 1716, and died on September 24, 1723.

THEOPHILUS COTTON, 1726, HAMPTON FALLS.
Cotton was the first minister of Hampton Falls. He graduated from Harvard in 1701 and preached at the Isle of Shoals before coming to Hampton Falls in 1711. Described by his brother as "probably the fattest man in the country," and constantly ill, he died in August 1726, after returning from a stint of preaching on the Isle of Shoals.

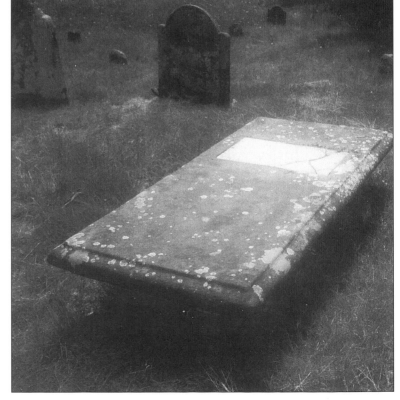

E.S., HAMPTON FALLS.
This unknown individual died as a result of the Throat Distemper epidemic of 1735–1740. Hampton Falls was the worst afflicted town in New Hampshire. Within one year, 210 people died, 200 of whom were under the age of 20. Fourteen families lost three children a piece. Eleven more families lost anywhere from four to seven children each.

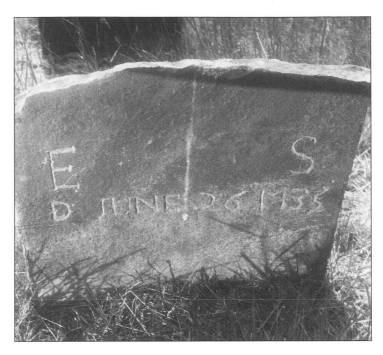

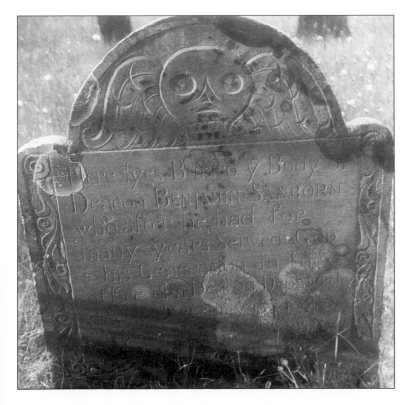

BENJAMIN SANBORN, 1740, HAMPTON FALLS. The accomplishments of the deceased are recounted on this simple gravestone, possibly carved by James Foster II. Sanborn "for many years Served God & his Generation in the office of Deacon . . ." Born December 20, 1668, the son of Lt. John Sanborn of Hampton, Benjamin had 3 wives and 12 children in his 71 years of life.

103

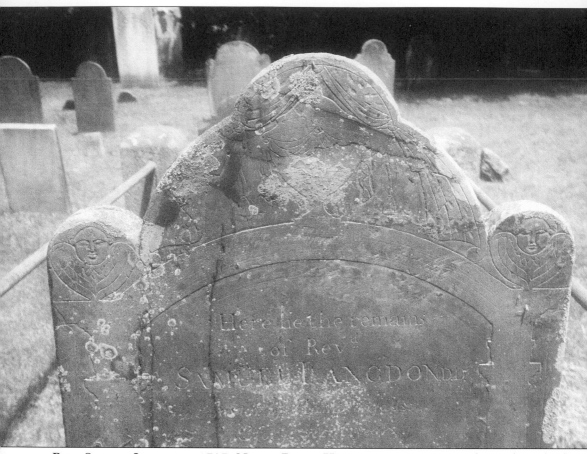

REV. SAMUEL LANGDON, 1797, NASON ROAD, HAMPTON FALLS. Reverend Langdon's final resting place is marked by this elegant Noyes carved stone. He was born in Boston on January 12, 1722/23, and graduated from Harvard in 1740. By 1744, he was a schoolmaster in Portsmouth and, in the spring of 1745, went to Louisburg as the chaplain of the New Hampshire regiment. In February 1747, he was ordained at North Church in Portsmouth. He left Portsmouth in July 1774 to become Harvard's 13th president. His term, punctuated by the social upheaval of the Revolution, lasted only six years. A committee, formed to remove Langdon from office, addressed him in these words, "As a man of genius and knowledge we respect you; as a man of piety and virtue we venerate you; as a President we despise you." Reverend Langdon came to Hampton Falls as minister in January 1787, and was the town's delegate to the Constitutional Convention in 1788. He died on November 29, 1797. His gravesite was, at one time, maintained by Harvard University.

Eight

SEABROOK,
KENSINGTON, SOUTH HAMPTON,
AND EAST KENSINGTON

Seabrook, originally part of Hampton and, subsequently, Hampton Falls, gained town status in 1768. The Old Quaker Burial Ground is within the confines of Elmwood Cemetery, on land given to the Quakers by Thomas Chase in 1701, the same year their meetinghouse was built. Many graves here are not marked, as it was not the Quaker practice to commemorate their dead by erecting gravestones.

Kensington, originally part of Hampton, was that town's Third Parish in 1732, when the first meetinghouse was built. In 1733, Elihu Chase granted 1 acre of land "For and in the consideration of the Love and Desire which I have for the building of a meeting-house." The meetinghouse was moved to a part of this land and was finished in 1734, while a half-acre was used for the burial ground, known as the "Upper Yard."

South Hampton, despite its name, has its origins in Massachusetts. It was originally part of Salisbury, and later Amesbury. When the state boundary line between Massachusetts and New Hampshire changed in 1741, the area fell within New Hampshire. In 1742, it was chartered as a separate town. The old burying ground was established there in 1726.

East Kingston was originally part of Hampton and, subsequently, Kingston. It became a separate town in 1738. Oak Hill Burial Ground was established shortly thereafter.

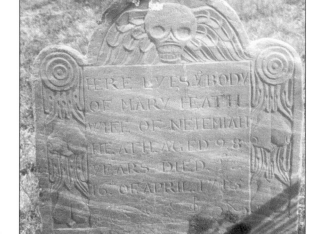

MARY HEATH, 1715, SEABROOK.
Mrs. Heath's gravestone was probably carved by Nathaniel Emmes of Boston. Mary's husband was Capt. Nehemiah Heath of Hampton Falls, originally of Haverhill, Massachusetts.

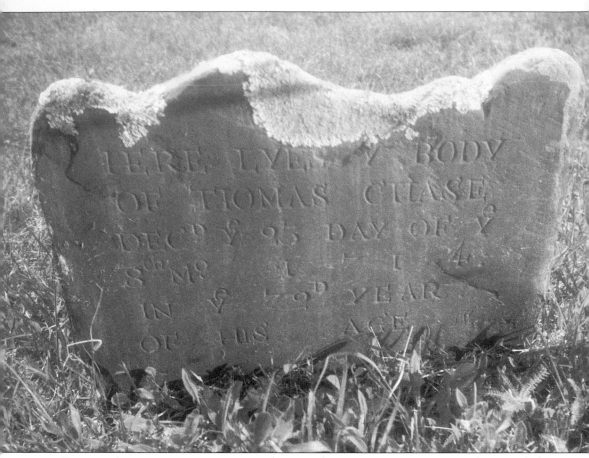

THOMAS CHASE, 1714, SEABROOK. Chase was born in Hampton, *c.* 1642, the son of Thomas Chase, a seaman who came there in 1639. The younger Thomas Chase was a Quaker preacher. Thomas Story, a fellow Quaker preacher, attended a Friends meeting at Hampton in 1704. He described Chase as "an old self-conceited, self-preferring, dead, dry, and confused preacher, of that place, and an enemy to the discipline of the Church." At the time of his death, Chase was unmarried and childless.

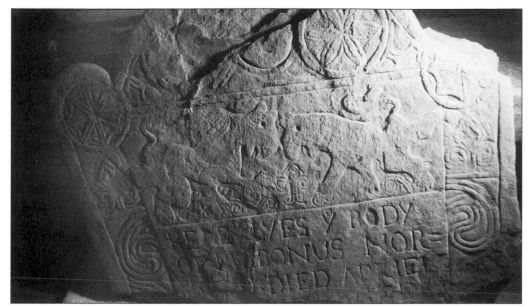

BONUS NORTEN, 1718, SEABROOK. Note the two large lions carved below the tympanum on this unusual gravestone carved by John Hartshorne. The lions may be a heraldic emblem for the Norten family. Bonus Norten, originally from Ipswich and Hingham, Massachusetts, moved to Hampton in 1695. He was a tavern keeper and merchant. Originally in the Old Quaker Burial Ground, this stone has been removed by the town for preservation purposes.

JOHN STANYAN, 1718, SEABROOK. Stanyan's stone has been removed by the town for safekeeping. It is the work of John Hartshorne. Stanyan was the son of glover Anthony Stanyan, who came to New England in 1635 on a ship called the *Planter*. John was born in Boston, in July 1642, and later came to Hampton.

ELISABETH GREEN, 1755, SEABROOK. The evenly carved lettering on this remarkably well-done, home-carved gravestone has survived the Seacoast's harsh climate for 230 years.

THANKFUL WEARE, 1798, SEABROOK. Note the delicacy of the design used on this stone, with the angel flanked by small funeral urns. It is the work of Jeremiah Lane of Hampton Falls.

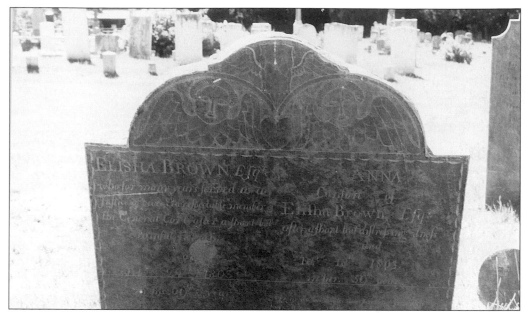

ELISHA AND ANNA BROWN, 1803, SEABROOK. The Noyes family carved this double gravestone for a husband and wife who died only four days apart, in February 1803. Both died "after a short but distressing illness." Elisha was a justice of the peace and a member of the General Court in New Hampshire.

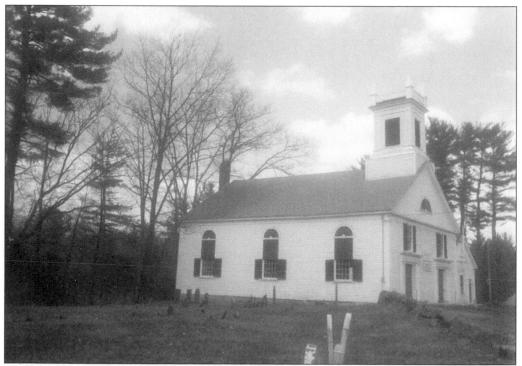

UNIVERSALIST CHURCH, KENSINGTON. The burial ground, known as the Upper Yard, is located next to the Universalist Church, built in 1840.

FOOTSTONE, EDWARD TUCKE, KENSINGTON. Only the footstone remains to mark Edward Tucke's grave. The carving is attributed to Johnathan Hartshorne. Tucke, born February 7, 1695, was the son of John Tucke, a Hampton carpenter and miller. Edward married the former Sarah Dearborn in November 1720 and had 11 children.

JOANAH SMITH, 1775, KENSINGTON. The distinctive frown on this gravestone is a distinguishing feature used by Jonathan Hartshorne. Joanah's stone was erected by her daughter, as evidenced by the lower part of the inscription, which reads, "This for the respect Ruth Lampre had to her DCST [deceased] mother."

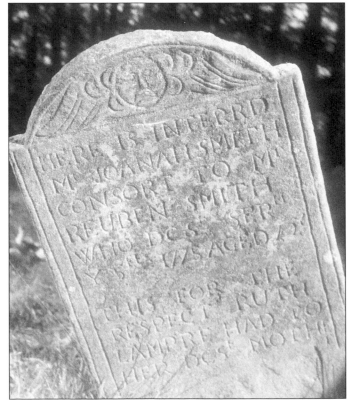

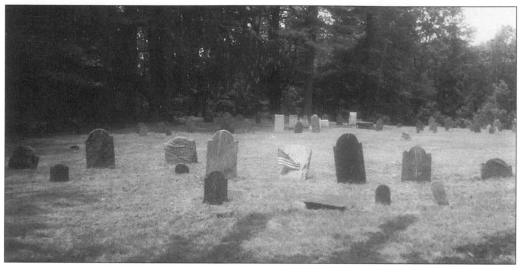

SOUTH HAMPTON BURIAL GROUND. This burial ground was established in 1727, when the area was part of Massachusetts.

ABIGAIL FRENCH, 1755, SOUTH HAMPTON. Abigail French's gravestone was carved by Moses Worster. The French family came to this area as far back as the 1680s. Young Abigail died "in ye 6 year of her age."

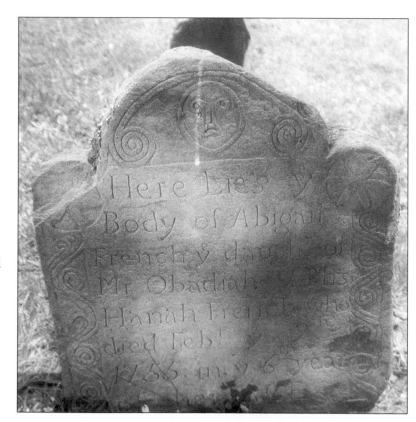

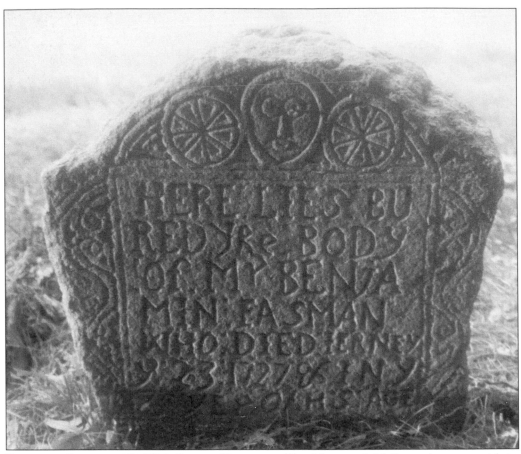

BENJAMIN EASMAN, 1727/28, SOUTH HAMPTON. This Merrimack Valley-style stone, with its unorthodox spelling, was probably the work of Robert Mullicken Sr. of Bradford, Massachusetts. The Mullickens succeeded John Hartshorne as the main carvers in the Merrimack Valley after Hartshorne moved to Connecticut *c.* 1722. Note the pie-shaped rosettes on either side of the outlined face and the scrolled borders.

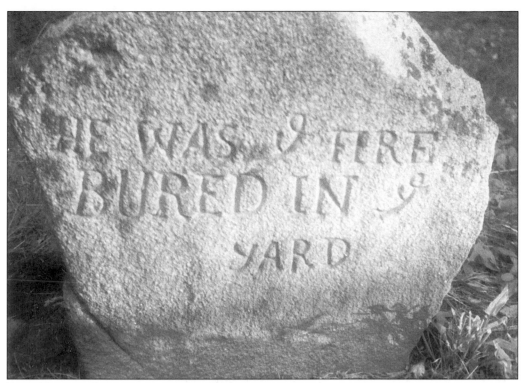

REAR FACE OF BENJAMIN EASMAN'S STONE, SOUTH HAMPTON. The inscription carved into the rear face of this stone distinguishes Easman as the first to be buried in this burial ground.

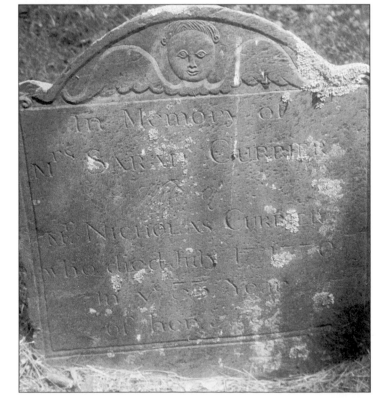

SARAH CURRIER, 1770, SOUTH HAMPTON. Note the bright-eyed, smiling expression on this gravestone, probably the work of a member of the Lamson family. Sarah was the wife of Nicholas Currier, a soldier under Capt. John Kingsbury at Crown Point in 1756. He also served in the American Revolution under Capt. Richard Titcomb, c. 1780.

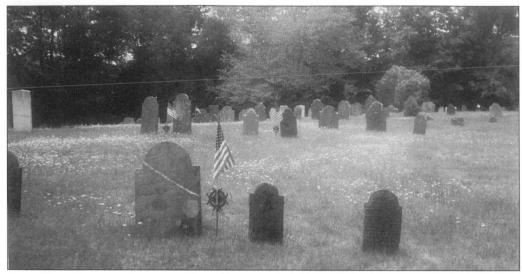

OAK HILL BURIAL GROUND, EAST KINGSTON. Many of the town's original settlers are buried here.

DANIEL CLOUGH, C. 1750s, EAST KINGSTON. Daniel Clough's gravestone is an unusual example of the Merrimack Valley style, carved out of sandstone by a member of the Webster family. Clough is descended from an early settler of Kingston. The inscription at the bottom of the stone reads, "[b]y one man shall Death come on all."

BENJAMIN MORRILL, 1754, EAST KINGSTON. Moses Worster carved this decorative gravestone for B. Morrill and a nearly identical one for Mrs. Morrill. The title "Incin," which appears before Benjamin's name, is creative spelling for the military rank of ensign, a rank that Morrill probably held in the local militia.

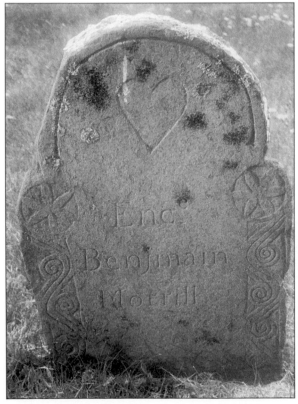

FOOTSTONE, BENJAMIN MORRILL, EAST KINGSTON. The side borders with acanthus leaves and scrolls match this footstone to its headstone. Note the unique heart motif.

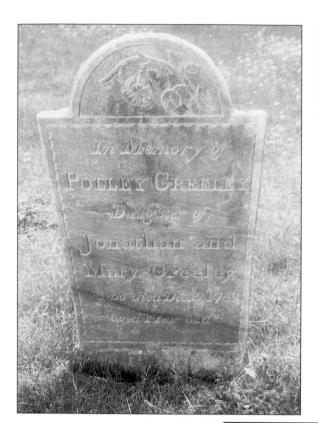

POLLEY GREELEY, 1782, EAST KINGSTON. The carver of this simple, yet elegant stone, with its unusual flower motif, is unknown, though it may have been Jeremiah Lane of Hampton Falls.

BETSY ROWE, 1800, EAST KINGSTON. The funeral urn motif on this gravestone carved by the Noyes family is typical of the early 19th century. The shape of the stone, however, is unusual, as are the broken limbs used to symbolize a young life cut short. Betsy, wife of Joseph Rowe, was only 22 when she died.

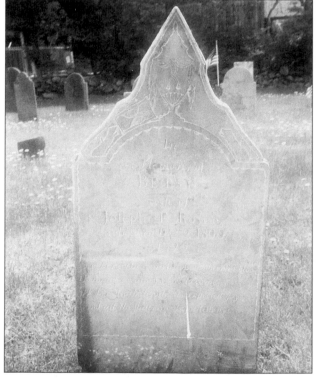

Nine

JEREMIAH LANE
STONECARVER OF HAMPTON FALLS

Jeremiah Lane is important as the only known gravestone carver native to the Seacoast region. Son of Deacon Joshua and Bathsheba (Robie) Lane, he was born in Hampton on March 10, 1732. He was one of 16 children. While his father was a cordwainer, Jeremiah took up the trade of a tailor. Little is known about Lane's early activities, but records indicate that he worked as a tailor into the early 1770s. About 1754, he moved to Hampton Falls, and it was here, in January 1759, that he married Mary, the daughter of Joseph Sanborn. During their 47 years together, they had six children. By 1776, Lane is referred to as a "yeoman" (a farmer). He is also referred to, in some records, as a "joiner."

Like many men of his day, Lane was a versatile and skilled man. Well versed in practical matters, he was also a thoughtful and religious man, as evidenced by the gravestones he carved. Lane started carving gravestones on a regular basis after the death of Newburyport carver Jonathan Hartshorne c. 1776. Lane perfected and refined his style of carving over a period of nearly 30 years, in addition to tending his own farm and serving the town in a variety of capacities. Jeremiah Lane died in 1806, at the age of 72. He is buried in the Nason Road burial ground, adjacent to his own homestead.

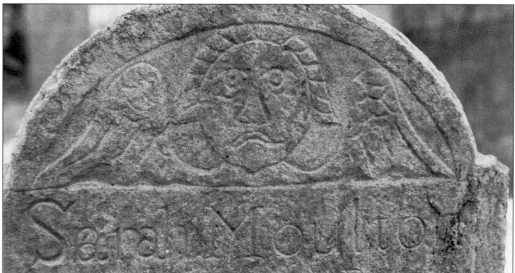

SARAH MOULTON, 1772, ROUTE 88, HAMPTON FALLS. Little Sarah was the "dater" of Captain Benjamin and Sarah Moulton. She died on April 20, 1772. Her gravestone is one of Lane's earliest works. The Moultons were neighbors of Jeremiah Lane.

JOSHUA LANE, 1766, PINE GROVE, HAMPTON. Deacon Joshua Lane was Jeremiah Lane's father. His stone, with its frowning face and fish-like eyes, was carved by Jonathan Hartshorne. Deacon Lane died on June 14, 1766, after being struck by lightning on his own doorstep. Jeremiah composed and read the funeral sermon for his father, which was published that same year (see below). Jeremiah began carving gravestones for friends and family about six years later.

A

MEMORIAL,

AND TEAR OF

Lamentation.

WITH THE

IMPROVEMENT

Of the Death of Pious Friends.

Hampton-Falls, July 17, 1766.

PORTSMOUTH, in New-Hampshire ;
Printed by D. & R. Fowle, 1766.

PREFACE.

THE following are some things which were suggesting to my mind, after the very heavy and melancholy tidings, of the death of so dear a Friend : and being desirous, if possible, to do something in honour to so faithful, and good friend ; that his remarkable example might not be forgotten, and buried with him ; but that his memory might be preserved, and blessed.—I thought with myself, in the morning before his funeral, (not having had opportunity before) that I would then take my pen, and spend the former part of that day, in writing somewhat relative thereto ; which after I had done, so far as time would allow ; was somewhat thoughtful of offering it to my brethren, and sisters, at the funeral, if a convenient opportunity should present ; but considering my inferior station in the brotherhood ; concluded to defer it, but communicating it in part to my younger brother ; was afterwards requested by my elder brother, to read the same ; by which I was then embolden'd thereto. But humbly, do I offer it to you, my brethren and sisters ; sensible of my own inferiority ; and desiring, that I may not be thought hereby, to pretend to any superiority among you. And do hereby express, my grateful acknowledgements, your kind acceptance of this my offering, and of your thus complying with the proposal.—And should I come under the inspection of others ; and even of learned, or whoever, of superior age, station or city ; they are welcome to peruse it : but as it is to be expected, neither do I pretend, to that correctness of speech, or composition, which might be expected from one of a liberal education ; there is therefore desired, all that christian charity, and favourable allowances that may appear needful.—I am sensible that this, or

PREFACE.

a piece of this kind, might have been much better composed, by some worthy hand ; and perhaps even by the same unworthy, had there been time therefor, and more deliberate contemplation thereon ; but this is what was then suggested to my mind ; altho' it is true as much more might have been added with equal propriety ; but it is not for me to multiply words ; I am fearful left I have exceeded herein already.

I have thought proper to style it a Tear of Lamentation, because composed with eyes full of tears, and a heart full of grief, by a very unworthy instrument,

Jeremiah Lane.

Hear ye Children the Instruction of a Father. Prov. 4. 1.

go the way of all the Earth, be [...] for and shew thy self a Man, make him an unce [...], and that to a g[...] Anby it he being Dead, yet ill'd him home ; when ed of his agreeable co [...] the Memory of the ..is wholesome counsels Prov. 10. 7. were continually dropp [...] ..ir lips ; and of his fervent pra The Gunications, and even wrestlings with [...] at the throne of grace for us, which we were ways reaping the benefit of, which we are to l upon as no small loss ; but that as our defence weakned upon this account, we are to look u ourselves, as doubly obliged to a close applica of ourselves to the throne of grace. And no we must see his pleasing face, his chearing c tenance, no more, nor hear his pleasant vo

FUNERAL SERMON FOR JOSHUA LANE, 1766. In this sermon, Lane states that his father was warned of the circumstances of his death back in 1740, when his house was struck by lightning. He writes, ". . . and here may we not discover the kindness of God to him, (that seeing this was the way in which he was to be call'd out of the world) in thus giving him warning beforehand, in causing his house over him to be rent and shatter'd by the same voice of his terror."

The Account of Discharge brought forward ————— £ s D 386 | 6 | 7

Paid Capt Caleb Sanborn ————————— 0 = 12 = 0

Paid Daniel Moody for Rates in Raimond ———— 3 = 5 = 8½

Pd Joseph Johnson for Tanning ——————— 0 = 18 = 0

pd Nehemiah Cram on Acct ——————— 1 = 7 = 0

pd James Rundlet Constable for Rates ——— 1 = 5 = 0

pd Cutting Silley Constable for Rates —— 7 = 15 = 0

pd the Apprisers for their Service ——— 3 = 0 = 0 15 | 2 | 8½

pd Jer: Lane on Acct 1/6 Ditto for Gravestones 2/ 1 = 5 = 6

PROBATE PAYMENT, BENJAMIN MOULTON, 1782. This court record shows that the estate of Capt. Moulton paid Jeremiah Lane for gravestones. Such records rarely go into specific details about gravestones, and, therefore, the identity of the carver is often unknown. Not so in this case, probably because Lane was acquainted with the Moulton family. Benjamin Moulton's stone still stands in the Moulton family plot on Route 88 in Hampton Falls.

ELIZABETH FOGG, 1779, UPPER YARD, KENSINGTON. The former Elizabeth Parsons of Salisbury, Massachusetts, married Rev. Jeremiah Fogg of Kensington on July 17, 1739. She came to her new home accompanied by her African-American servant, Phyllis. Reverend Fogg, having become "querulous" with his parish after Elizabeth's death, died in 1789. Note how Lane used Roman numerals for the age of the deceased, and the Biblical verse below, done in cursive.

Kensington in new England 1776

Jeremiah Lane falls...

To Cal, Rheu Jallap, Balspoly

To Emp. Ed. 1 g. alex Journey 8 8 6

Jeremiah Lane 4 4 8 6
To Calomel & Jallap 1 15.

Jeremiah Lane Dr To advice

Jeremiah Lane fr... 210

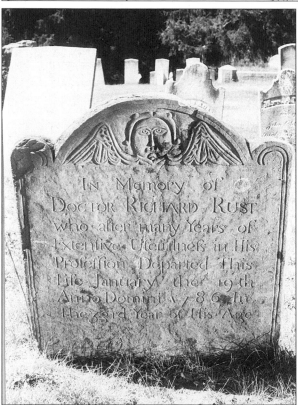

ACCOUNT BOOK, DR. BENJAMIN ROWE. Jeremiah Lane was acquainted with some of the area's most prominent men. He carved gravestones for three area doctors, including Dr. Benjamin Rowe of Kensington. Lane was Rowe's patient and received many services from him. Those listed in this account book include various herbal remedies (calomel, jallap, and balspoly), "advice," and a tooth extraction.

DOCTOR RICHARD RUST, 1786, STRATHAM. Richard Rust was the son of Stratham's first minister, Rev. Henry Rust, and Anna (Waldron) Rust. On May 20, 1733, Anna died of a fever, after an illness of 20 days within a month of Richard's birth. Richard married the former Martha Wiggin but had no children. Doctor Rust died in 1786, "after many Years of Extensive Usefulness in His Profession."

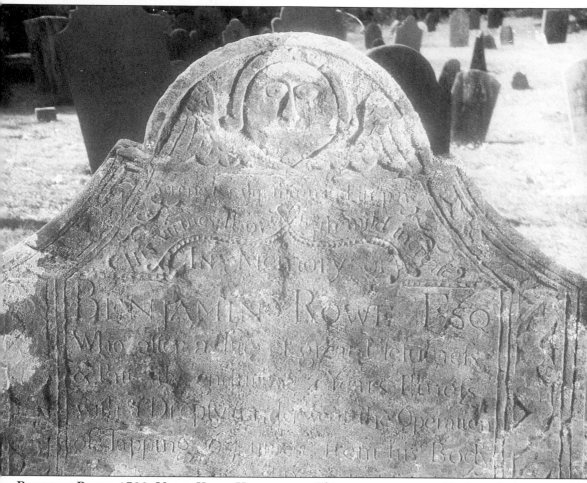

BENJAMIN ROWE, 1790, UPPER YARD, KENSINGTON. This worn stone, carved by Lane for his friend and physician, is one of the most famous gravestones in New England. The shape of the stone differs from Lane's other works, and he used a unique heart and scroll design. Most notable is the elaborate, extensive inscription, which reads, "Serene calm the Mind in Peace / His Virtues shown with mild increase / In Memory of Benjamin Rowe, Esq. / Who after a life of great usefulness / & Patiently enduring for years of illness / with a dropseye Underwent the operation / of Tapping 67 times. From his Body / was drawn 2385 pounds of water / Quietly departed this life the 28th day / Of March Anno Domino 1790 in his 71st Year." Dr. Rowe also served the town as a schoolteacher, beginning in 1742, teaching out of his own home. His son, also Benjamin, was an assistant surgeon in the Revolutionary War.

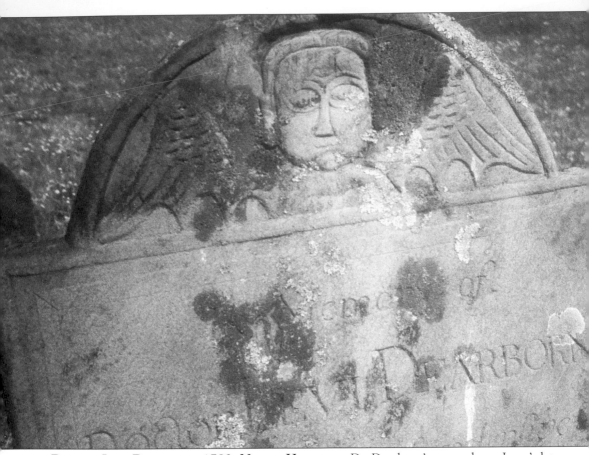

DOCTOR LEVI DEARBORN, 1792, NORTH HAMPTON. Dr. Dearborn's stone shows Lane's later style. Note the angel's bat-like wings, squarish head, and calm serene expression. There are no decorated side borders. Levi, the son of Joseph Dearborn, was born in March 1730, and was a 1756 Harvard graduate. He served gallantly as a surgeon in the American Revolution. He was in Col. Abraham Drake's militia regiment in 1777 at the Battle of Saratoga and in Col. Moses Nichols's regiment in 1778 in the Battle of Rhode Island. One record of his surgery during the war reads as follows, "Capt. Nathan Sandborn . . . at Bemus Heights . . . on the 7th Day of October 1777 Receivd a musket ball from the Enemy which entered his Shoulder near his Brest and I Extracted it out under the blade, Levi Dearborn Surgeon."

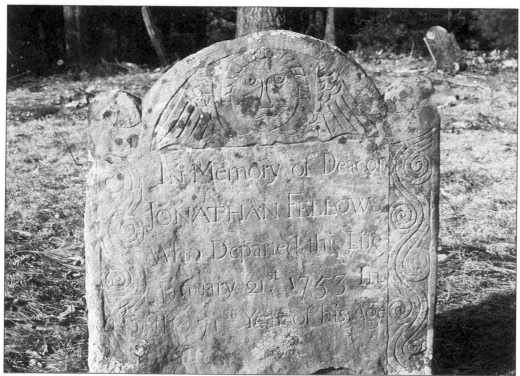

DEACON JONATHAN FELLOWS, 1753, UPPER YARD, KENSINGTON. Carved by Lane in the 1770s, this is a back dated stone. Deacon Fellows's son, Jonathan Jr., was a blacksmith of Kensington and counted Jeremiah Lane as one of his customers, and also provided compass needles, clock hinges, and gun "mending." Lane may have carved this gravestone in return for services provided by Fellows.

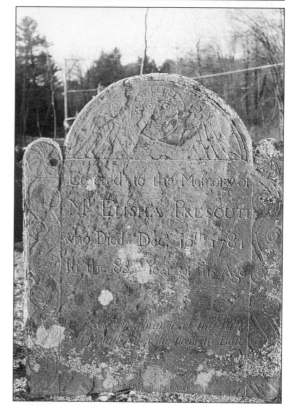

ELISHA PRESCUTT, 1781, NASON ROAD, HAMPTON FALLS. Elisha Prescutt's gravestone is an example of the best of Lane's early carving style. Note the pinwheels at the top of the side borders and the sorrowful expression on the angel's face. The inscription at the bottom of the stone reads, "The first Body Interr'd in this Burying Yard—1781."

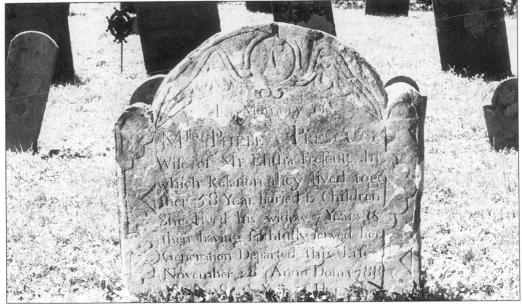

PHEBE PRESCUTT, 1788, NASON ROAD, HAMPTON FALLS. Because Lane lived and worked among the people whose stones he carved, he knew them well. This is reflected in his wonderfully detailed inscriptions. The former Phebe Sanborn married Elisha Prescutt on February 13, 1723/24. Ten of their thirteen children died young, some, no doubt, during the Throat Distemper epidemic.

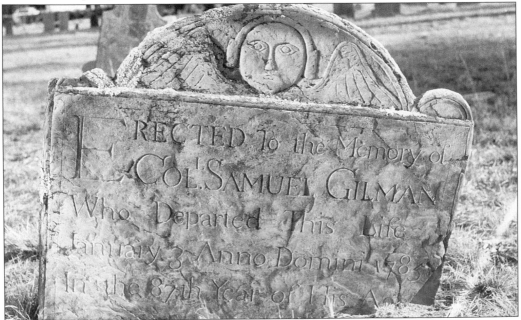

COL. SAMUEL GILMAN, 1785, FRONT STREET, EXETER. The gravestone that Lane carved for this prominent member of the Gilman family reflects the changes that he made in his style. No longer are the decorated side borders and frowning angel present. Lane turned his focus to perfecting his lettering. Note the distinctive, oversize letter "E" at the beginning of the inscription.

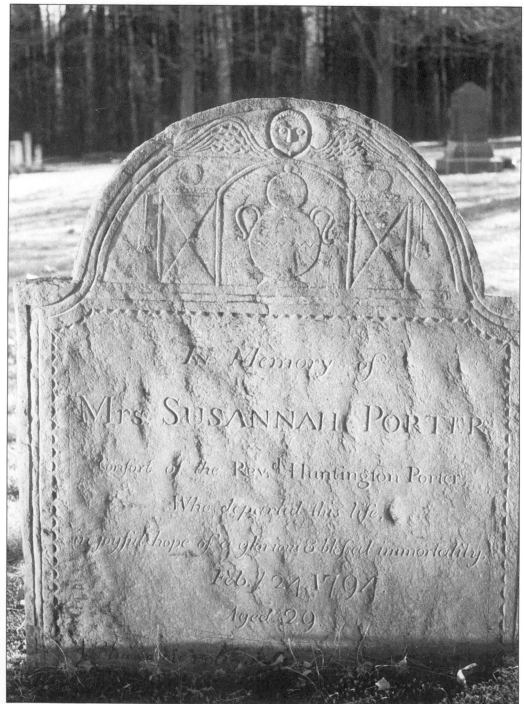

SUSANNAH PORTER, 1794, RYE. Susannah was the young wife of Rye's third minister. Lane carved only one other gravestone like this unique work. Note the interesting imagery, such as the funeral urn flanked by hourglasses, which are, in turn, flanked by tassels. Above the urn is an exquisitely carved angel, with a round head and faint smile.

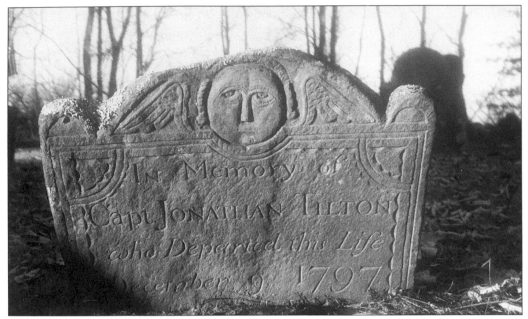

CAPT. JONATHAN TILTON, 1797, NASON ROAD, HAMPTON FALLS. By the late 1790s, the angels Lane carved became smaller and more compact, with peaceful, serene faces. Captain Tilton was a soldier of the American Revolution, serving on Peirce Island in Portsmouth in 1775 as a militiaman in New York in 1776 and in the Rhode Island campaigns in 1777 and 1778.

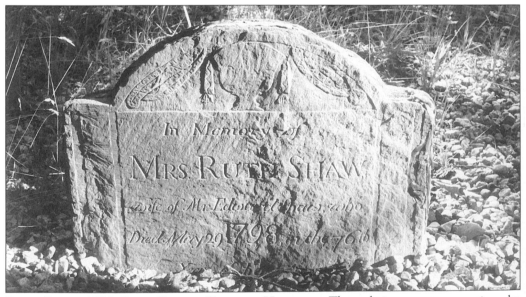

RUTH SHAW, 1798, SHAW BURIAL GROUND, HAMPTON. The style in gravestone motives, by this date, tended toward the use of the urn and willow and away from the use of angels. Lane's works were, in general, exceptions to this trend. But, for Ruth Shaw's stone, Lane gave up the angel motif and used a funeral urn flanked by tassels. The former Ruth Fellows married Edward Shaw of Hampton on May 7, 1746. Son Ichabod served under John Paul Jones and died during the American Revolution.

BILLY DODGE, 1798, OLD BURIAL GROUND, HAMPTON FALLS. This unusual, Lane-carved gravestone shows a small angel rising out of a funeral urn, which is embellished with tassels and surrounded by drapery. The striking imagery of death and resurrection depicted here seems especially appropriate for young Billy, only two years old when he died.

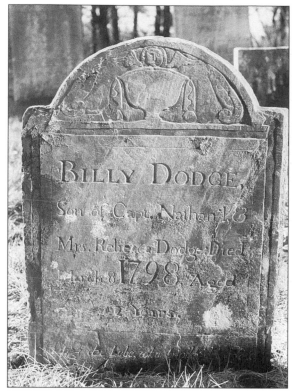

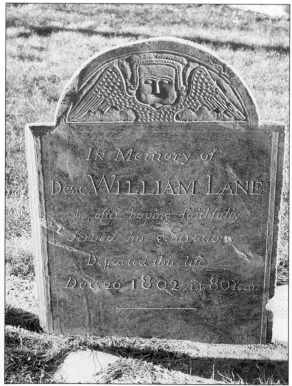

WILLIAM LANE, 1802, RING SWAMP CEMETERY, HAMPTON. Jeremiah Lane carved several gravestones for members of his own family. William was an older brother, born January 1, 1723. He was a tanner and shoemaker. A deacon in the church, William married "beautiful" Rachel Ward on February 13, 1746, and they had seven children.

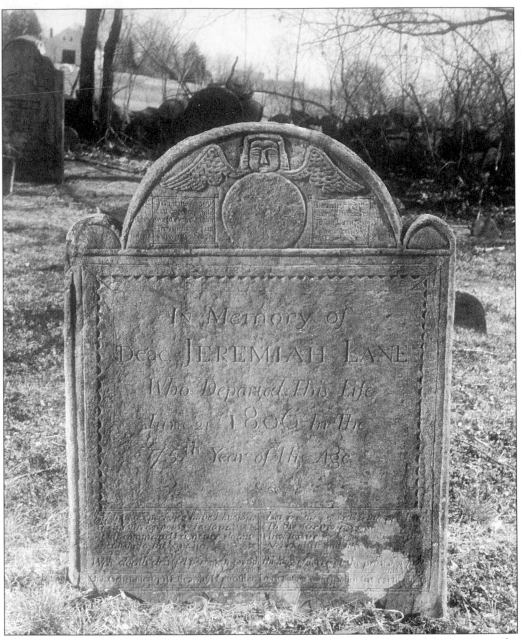

JEREMIAH LANE, 1806, NASON ROAD, HAMPTON FALLS. Lane carved this elaborate stone for himself at some point prior to his death. One of his sons probably carved in the appropriate dates after Jeremiah's death. The art of gravestone carving in the Seacoast area seemed to die out with him. Perhaps Lane's best epitaph was the recollection of a family member who, after seeing Jeremiah and four of his brothers together, remarked, "[t]hey were truly a patriarchal looking band . . . They were easy in their manners and moderately sociable . . . talking enough to make conversation agreeable, entertaining, and instructive . . . They were all persons of highly respectable character . . . Their work was of the best quality and commanded the highest prices . . . strictly honest in their dealings, careful in making promises and faithful in keeping them."